How to Draw Sea Animals

(A step- by- step guide to draw Shark, Octopus, Lionfish and many many more)

By Alex Man

Copyright © 2017 Alex Man
All rights reserved. No part of this publication may be reproduced, distributed, or transmitted in any form or by any means, including photocopying, recording, or other electronic or mechanical methods, without the prior written permission of the author.

Everyone can draw!
Drawing is like music, a universal language.
In this book I will show you,
step by step,
how to draw sea animals.

The instruction are given only by drawings,
so there is no need to add text,
that way even young children
can use the book by themselves.

On each page you can find a different animal.
On one page you have the directions on how to draw,
and on the following page the drawing with its environment,
as a part of the whole picture.

I put a lot of effort into this book,
trying to make the drawings easy,
 and accessible for all, and most importantly- fun for all!
Hope you will enjoy.
So... grab a sheet of paper and a pencil,
and let's dive into the world of sea animals.

Sincerely yours,
Alex

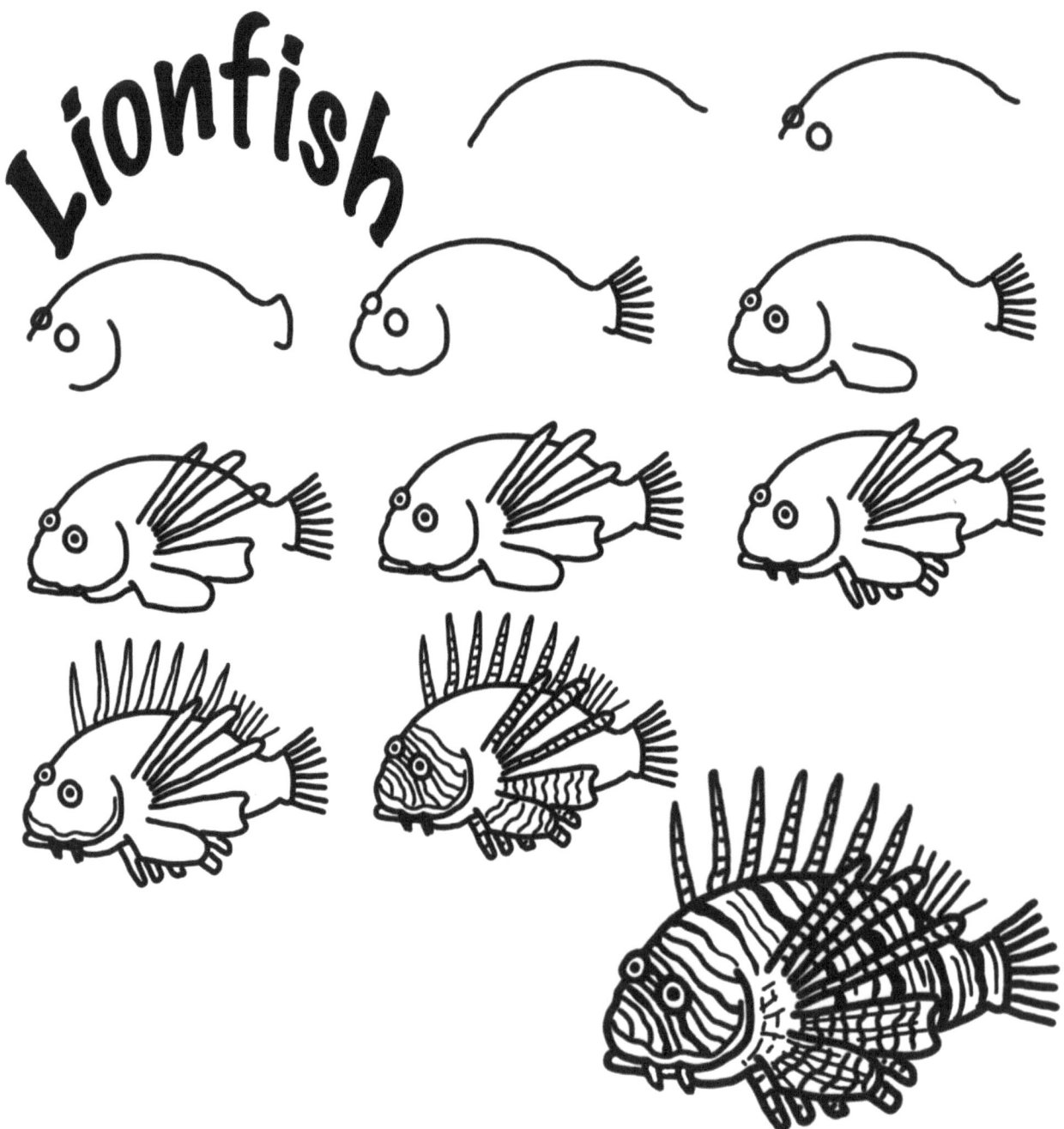

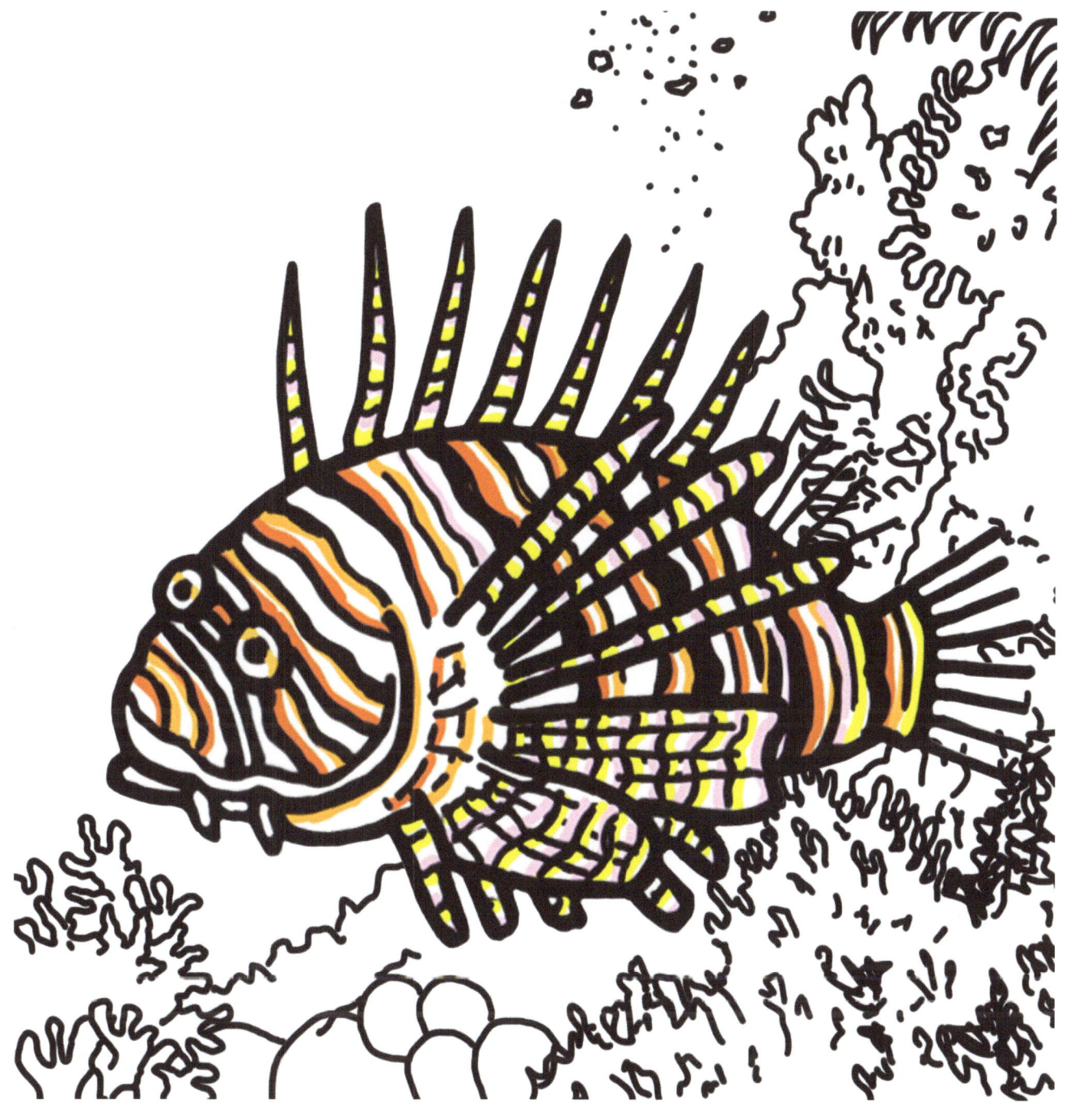

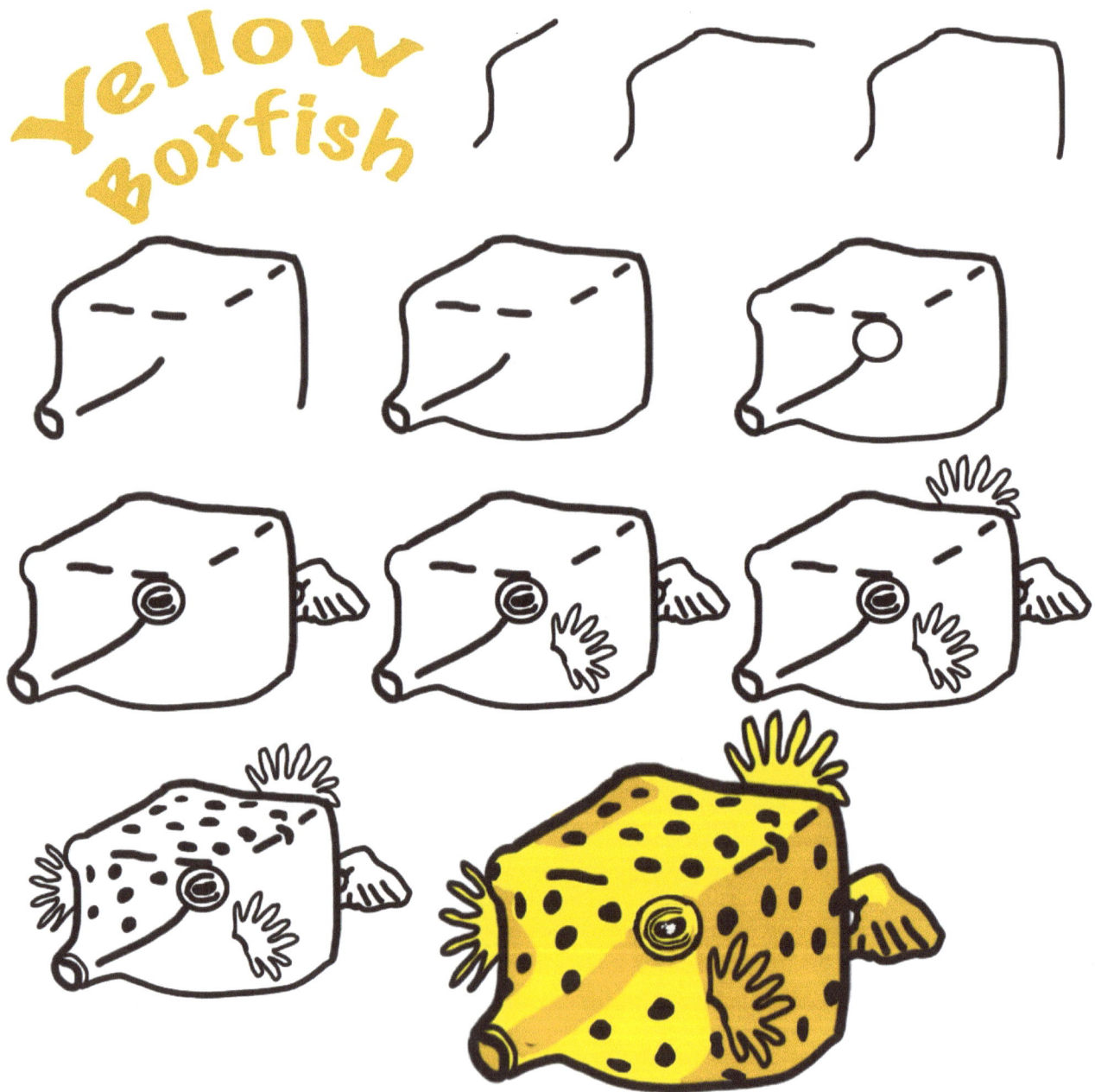

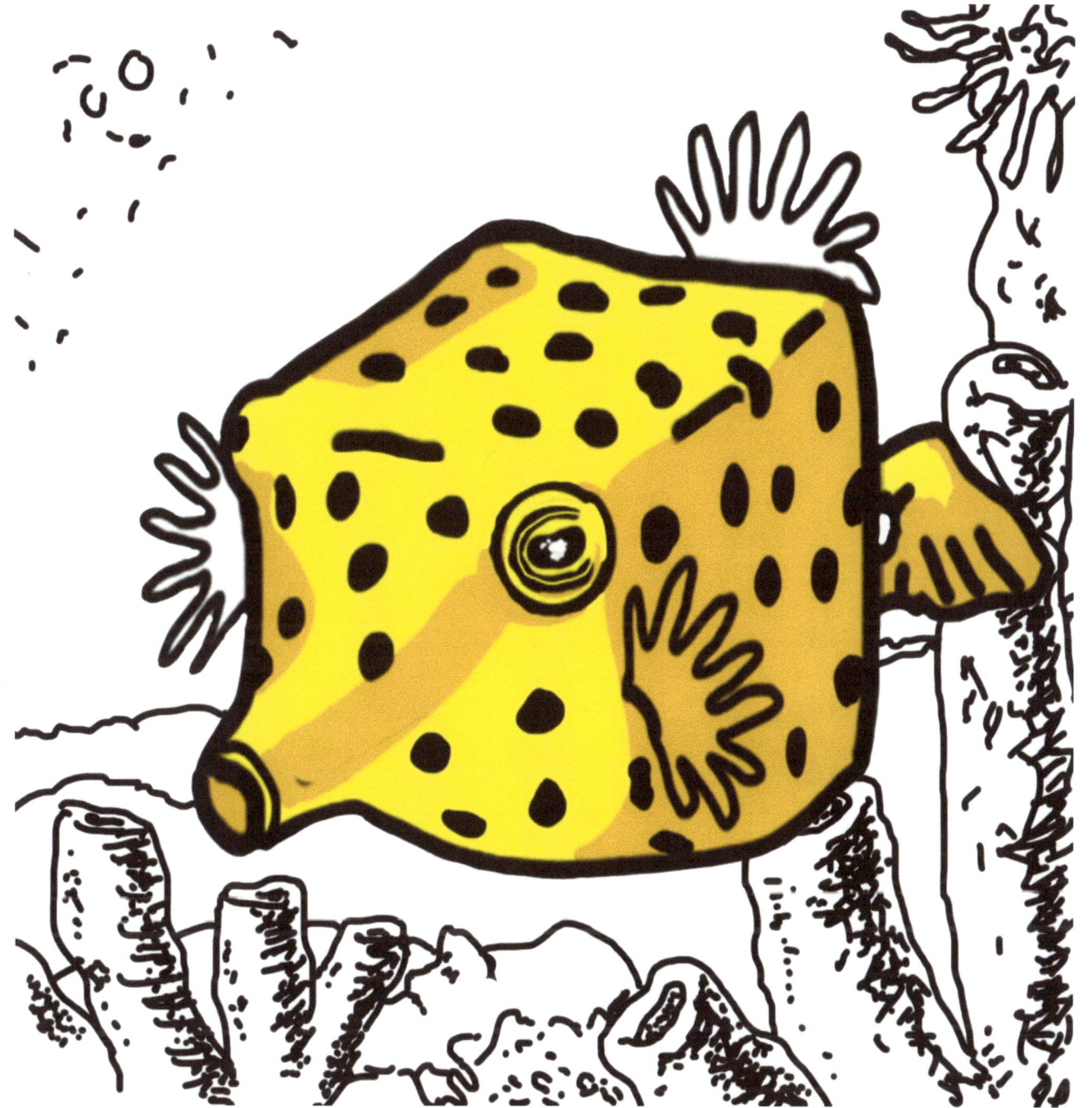

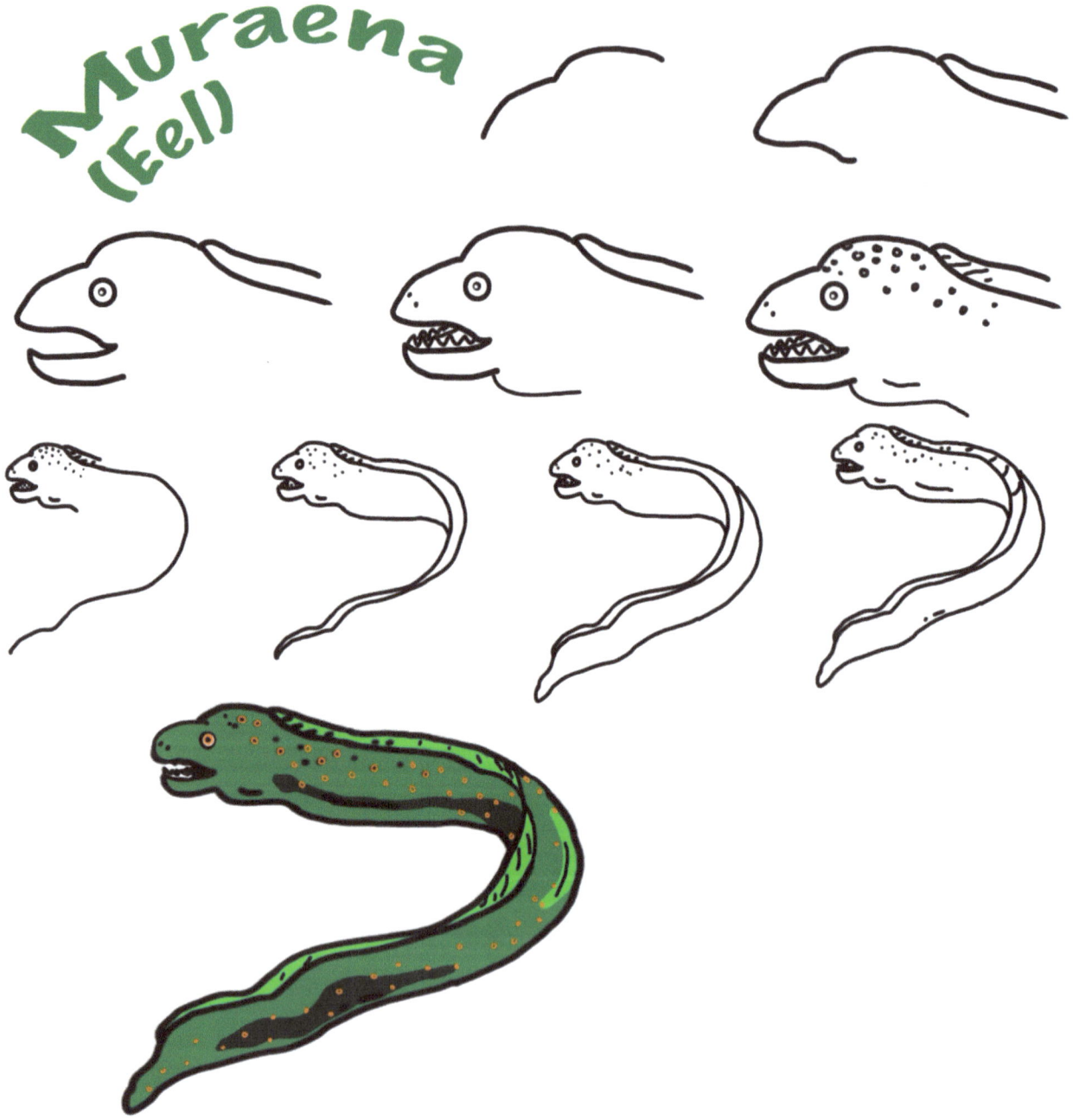

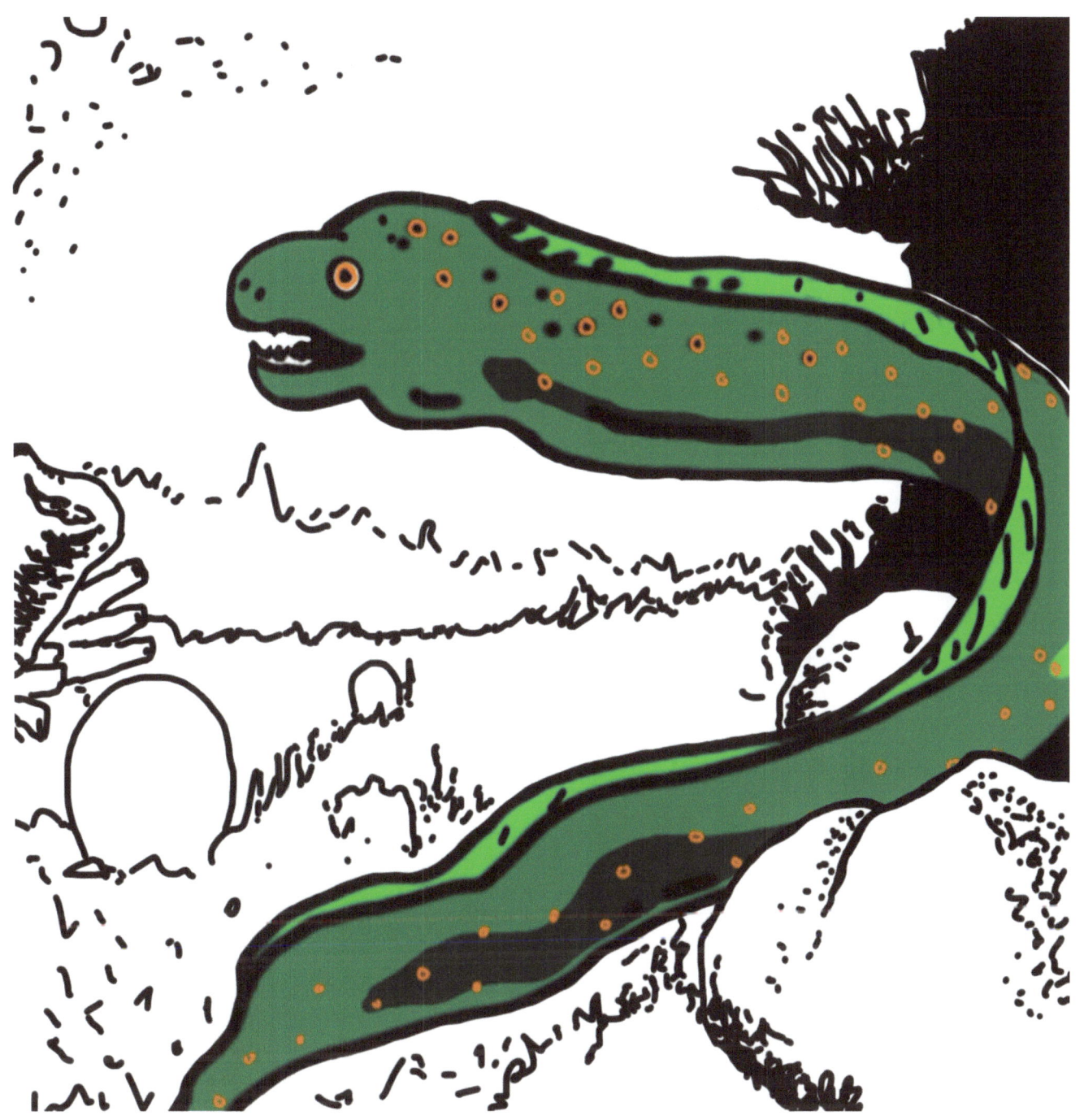

Sea Turtle

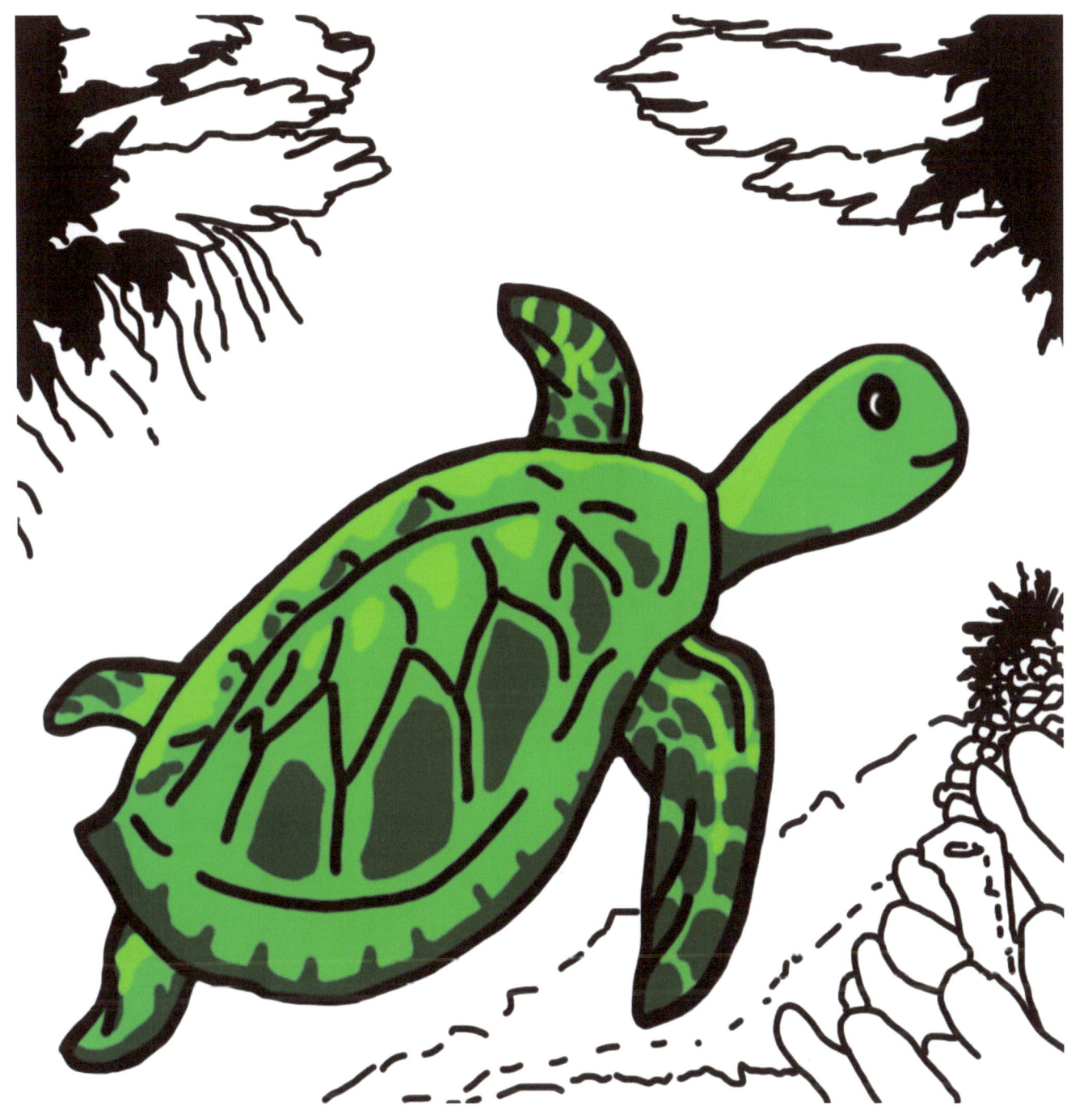

Shark

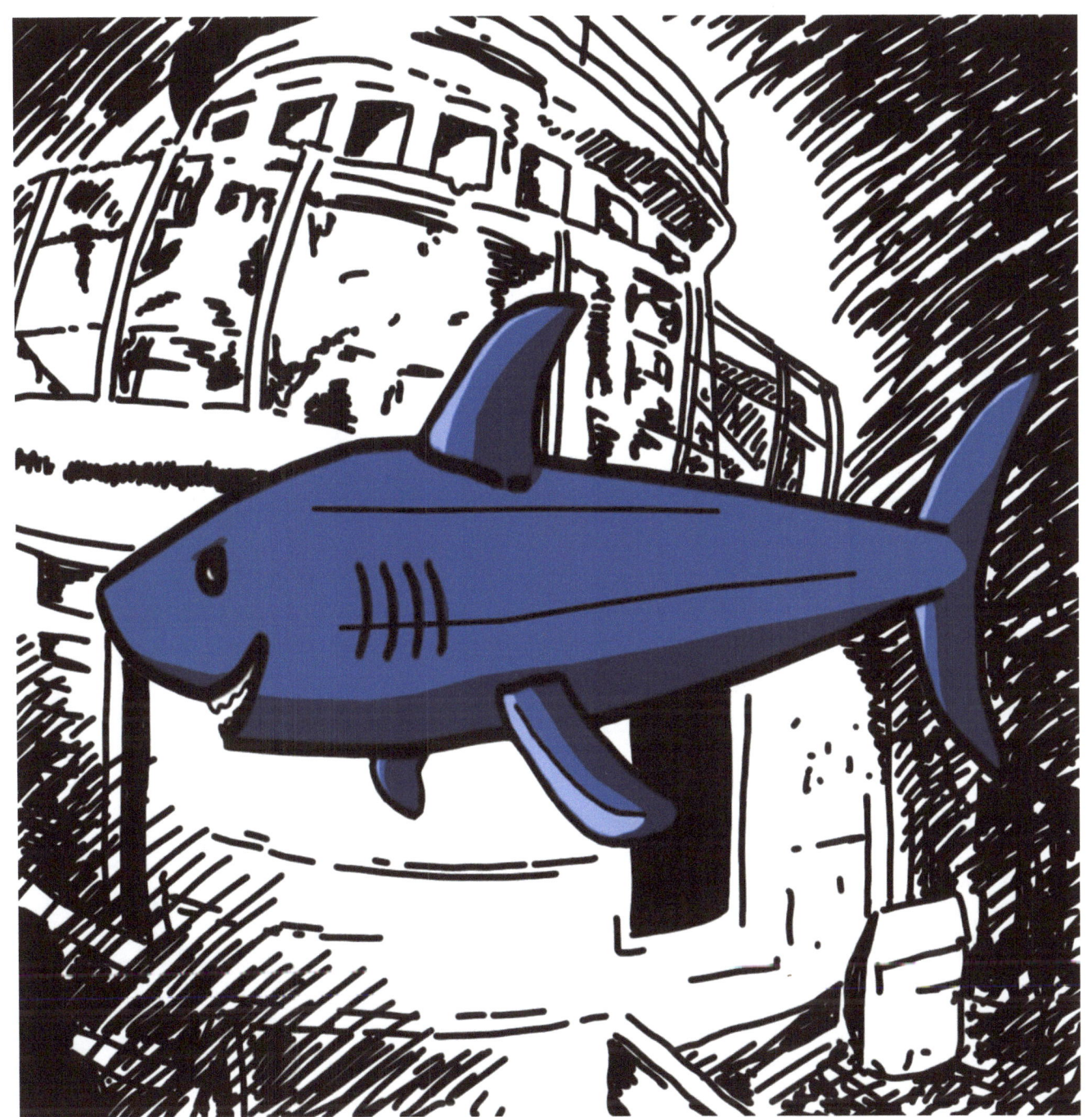

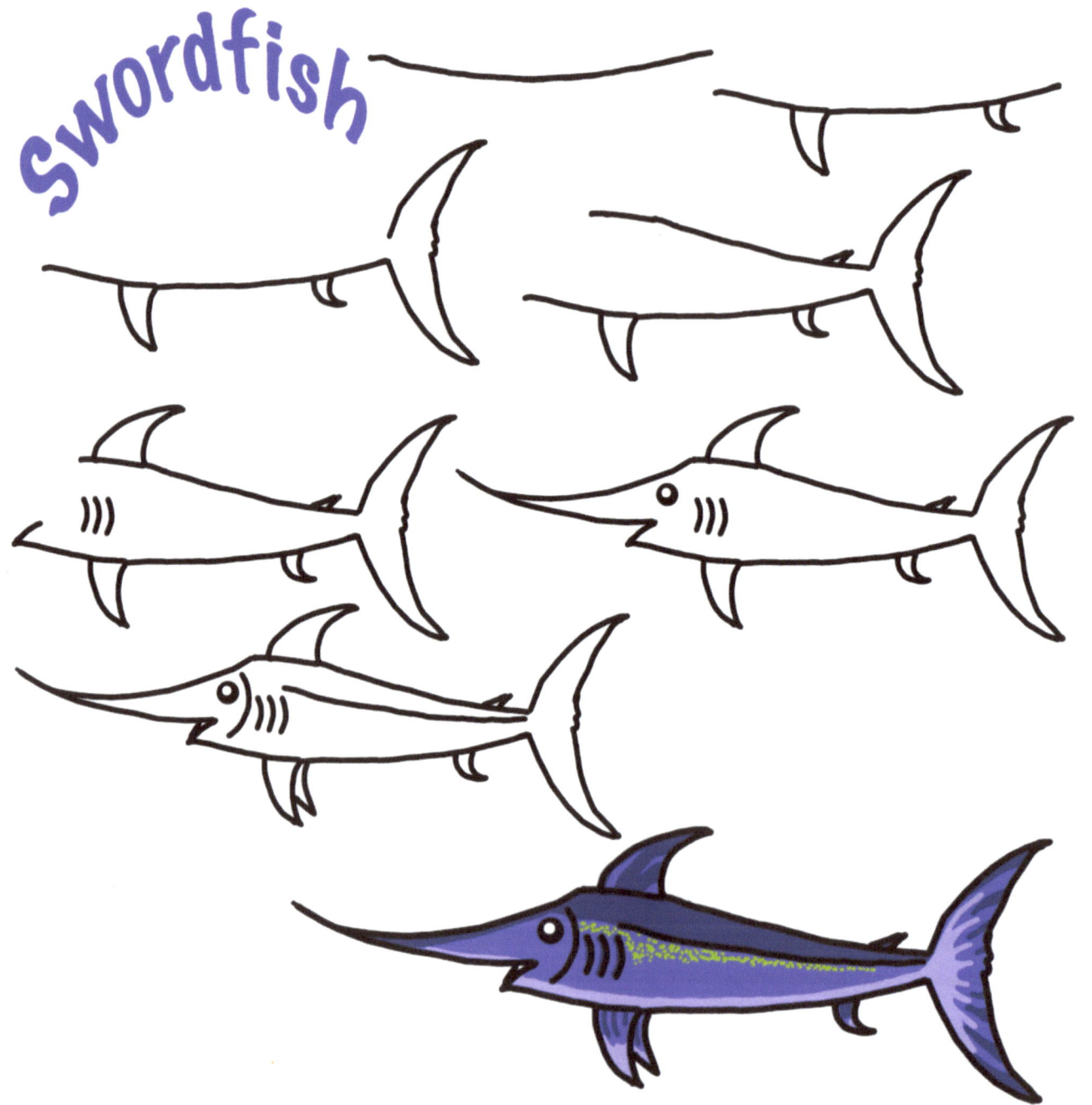

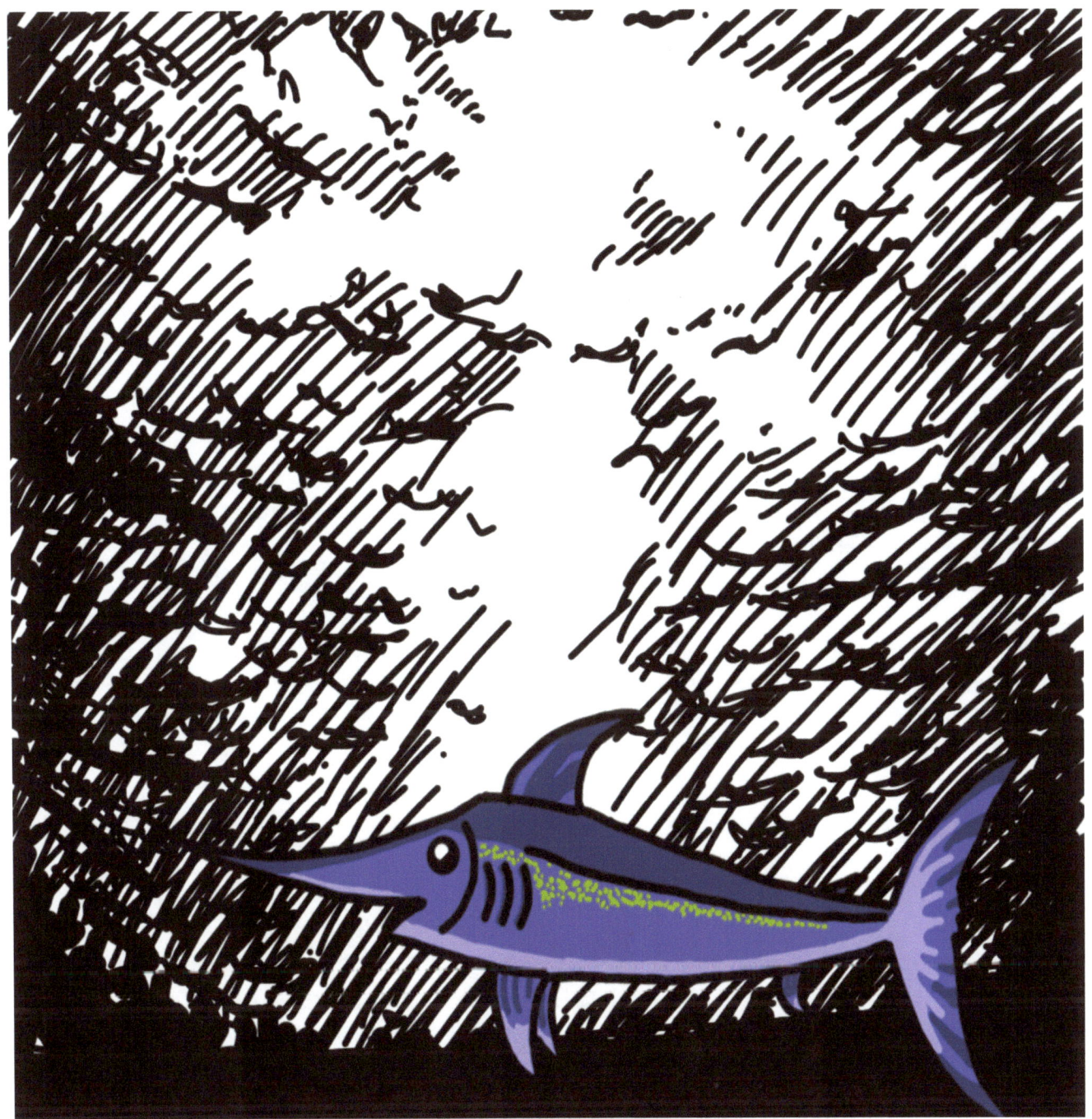

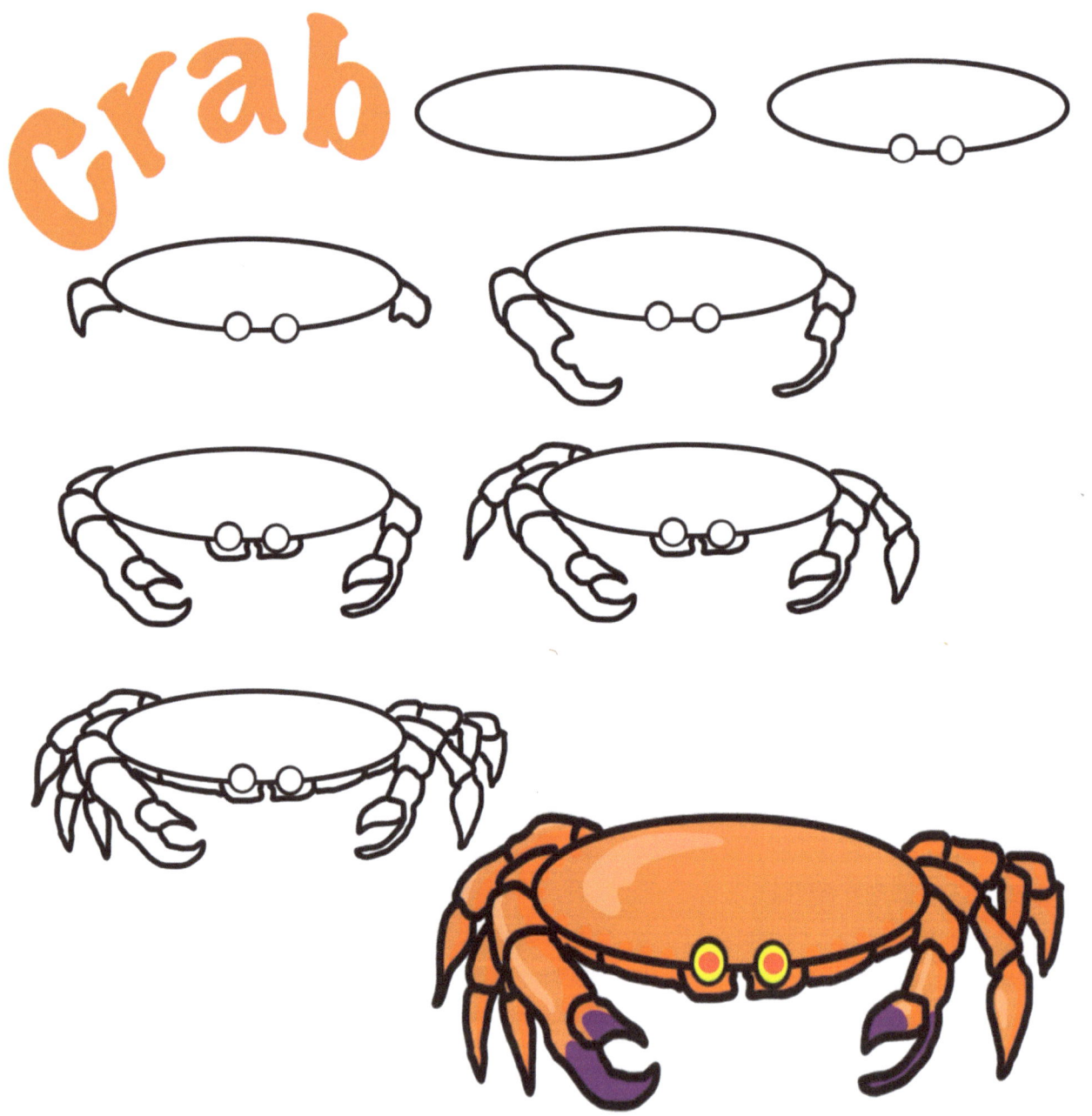

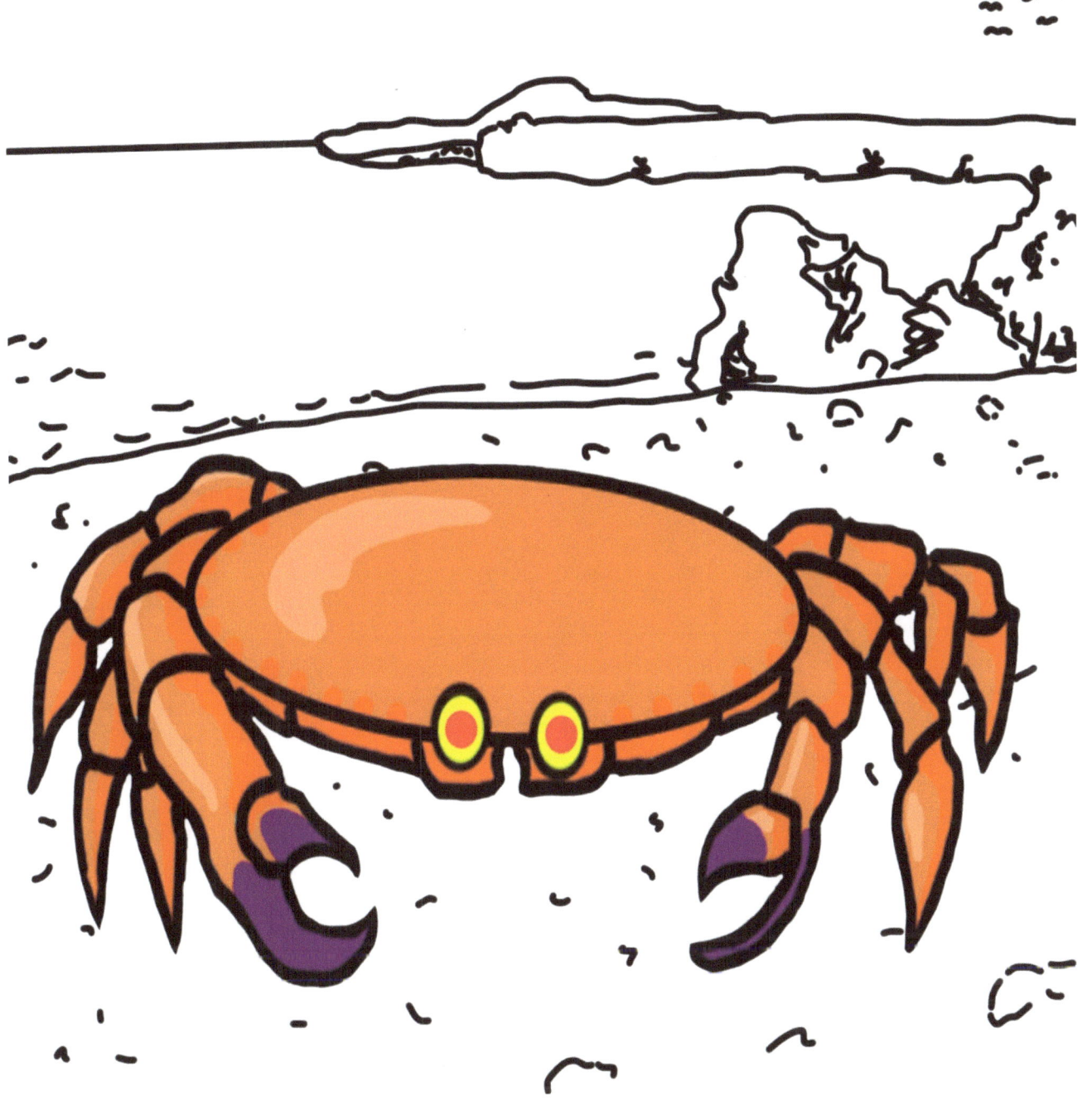

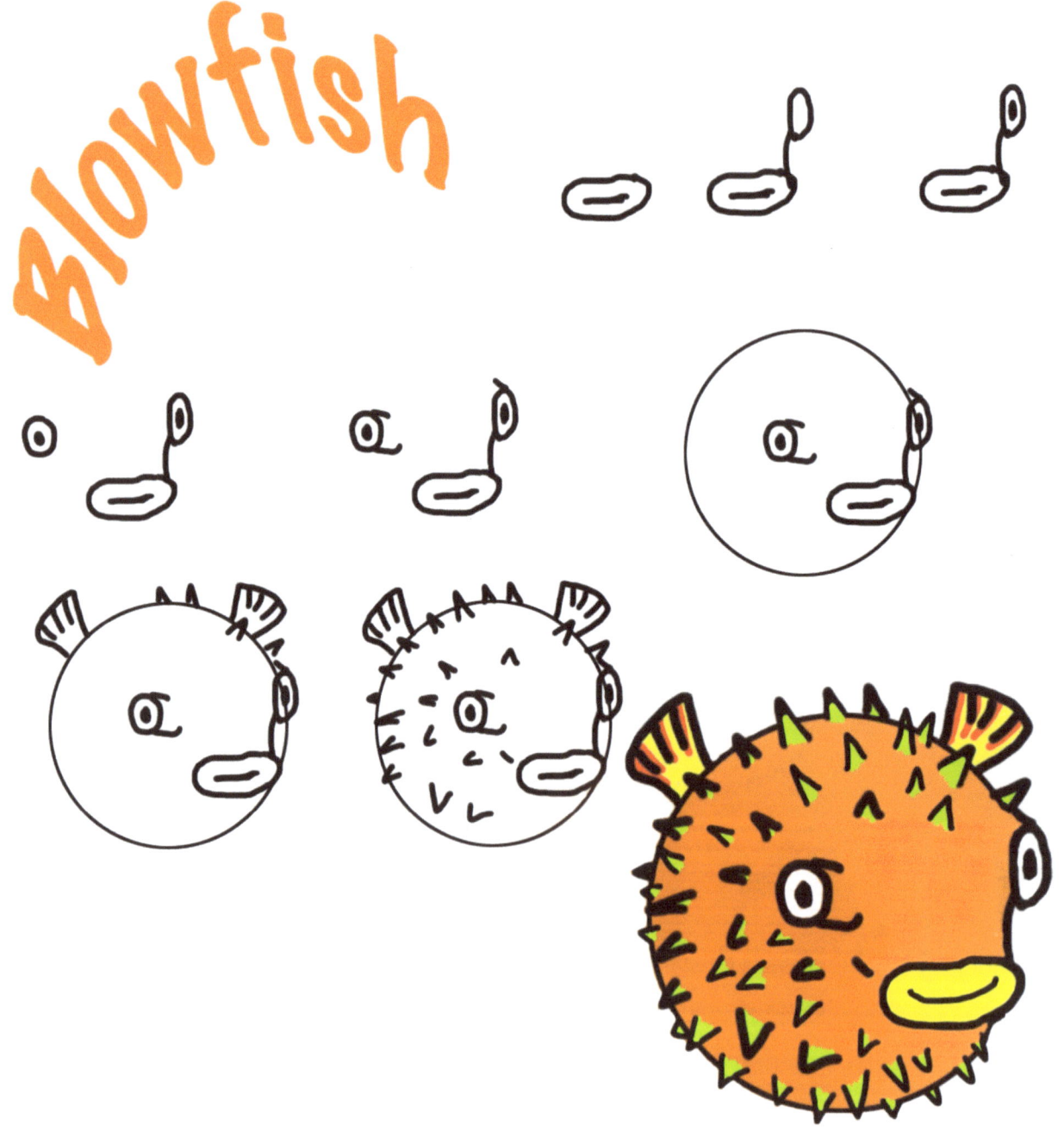

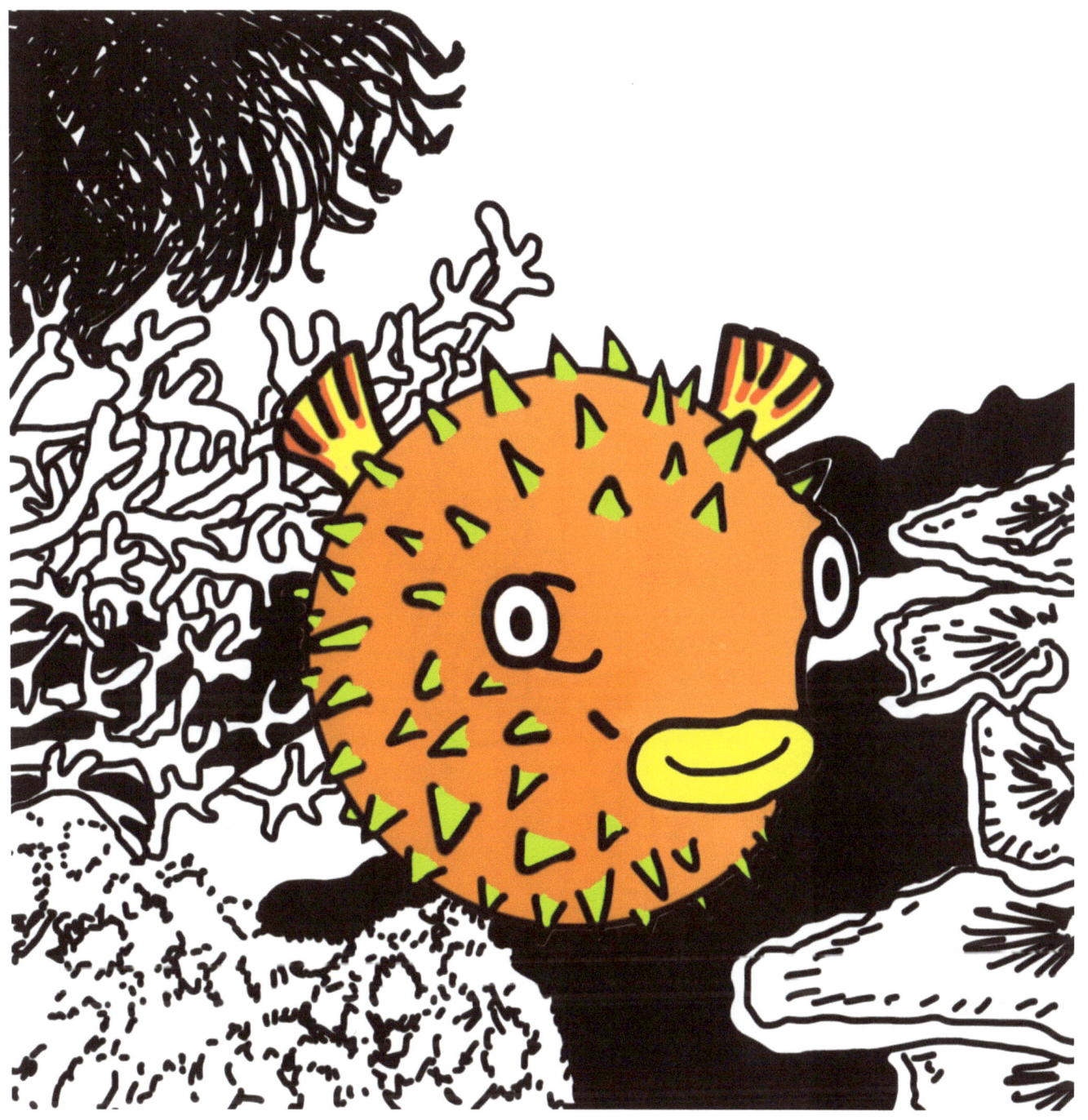

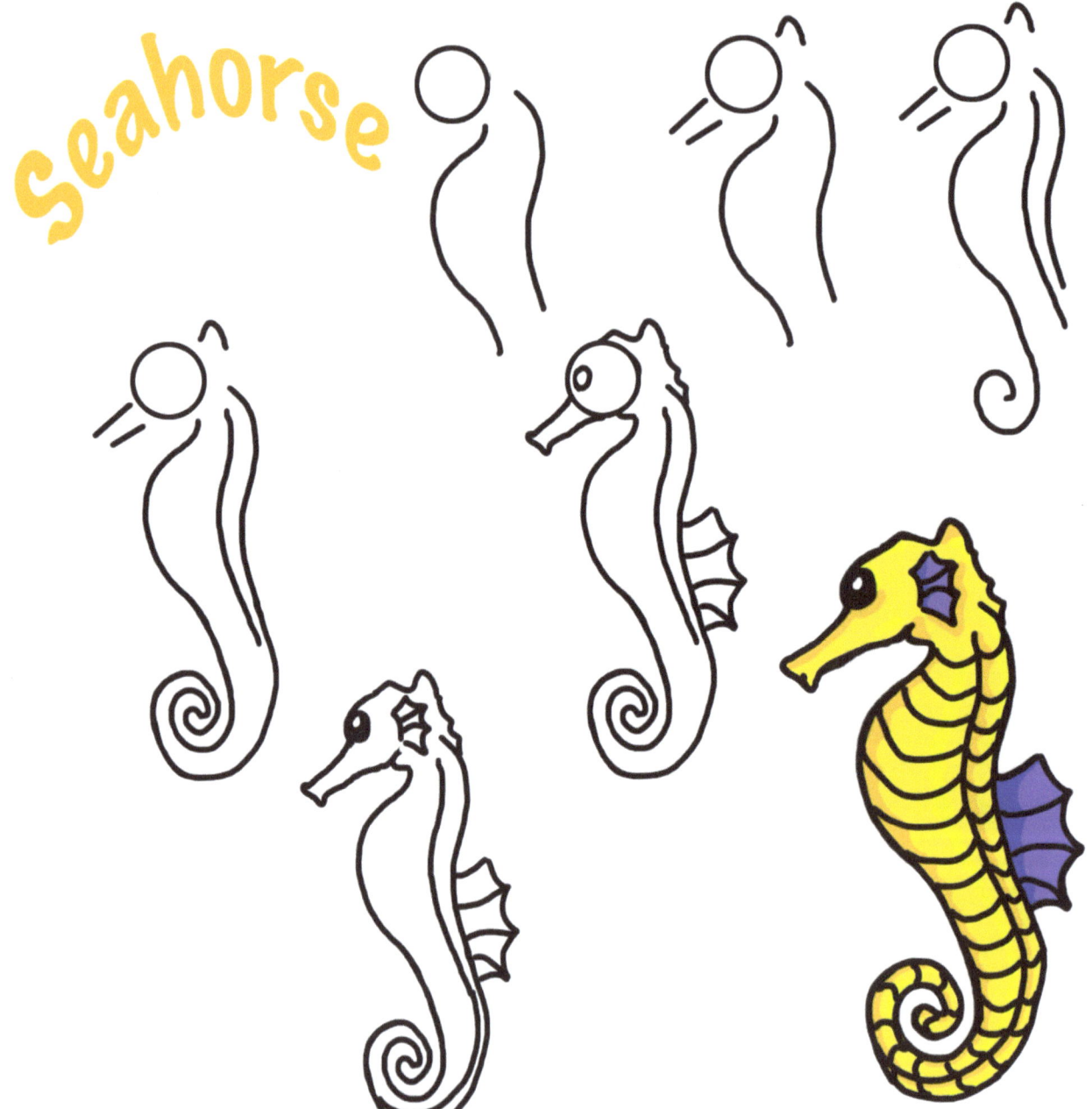

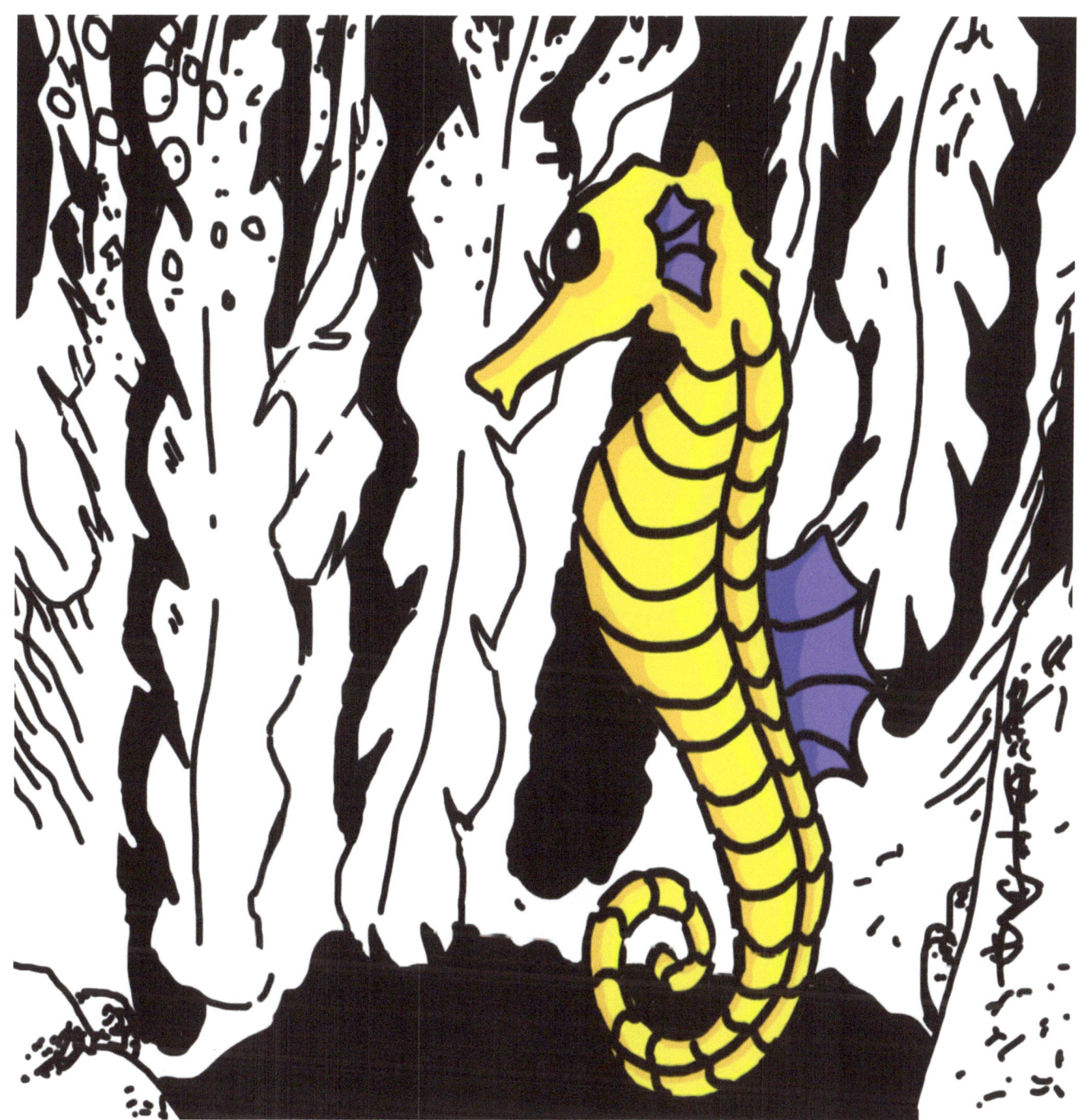

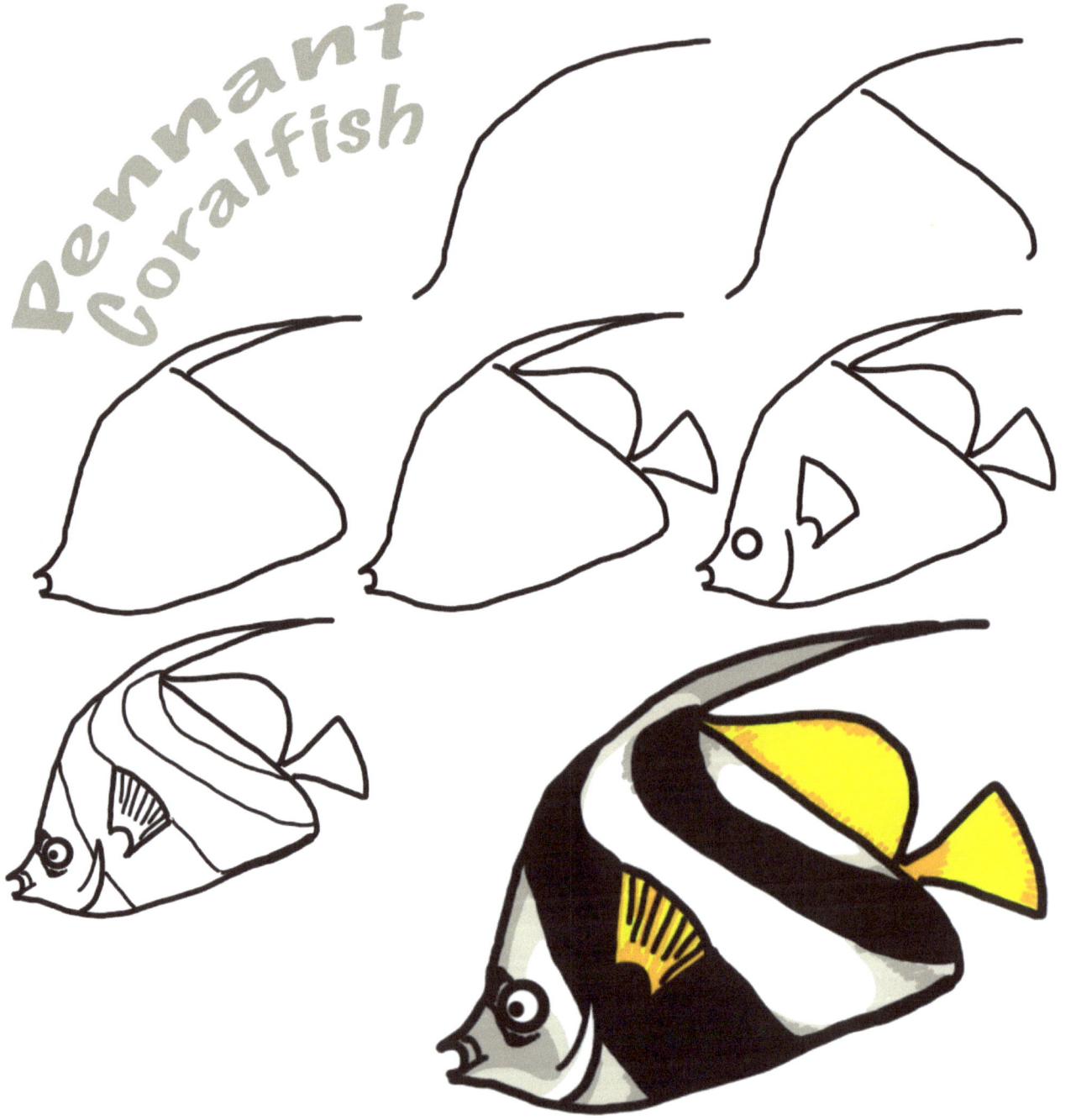

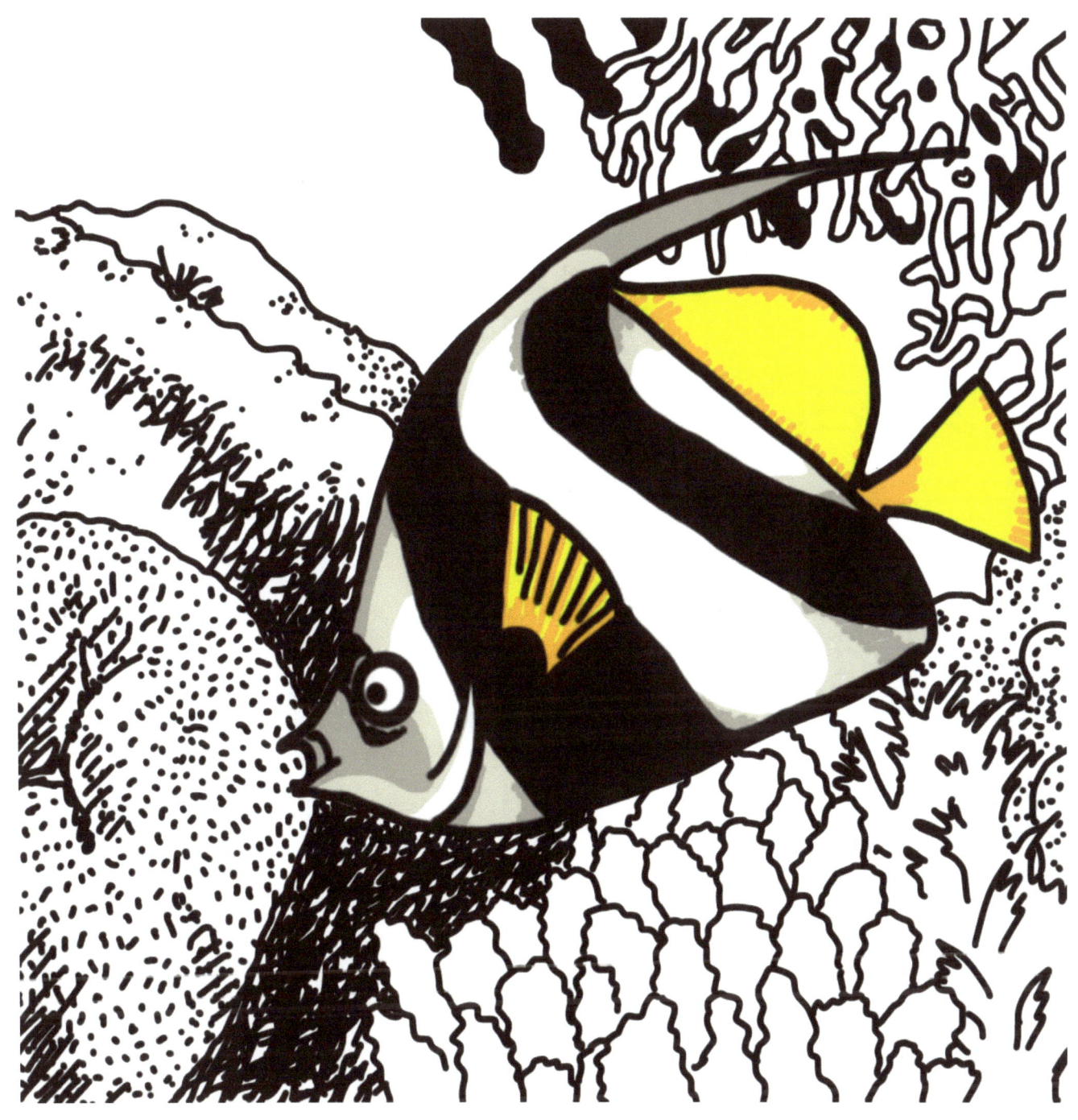

Jellyfish

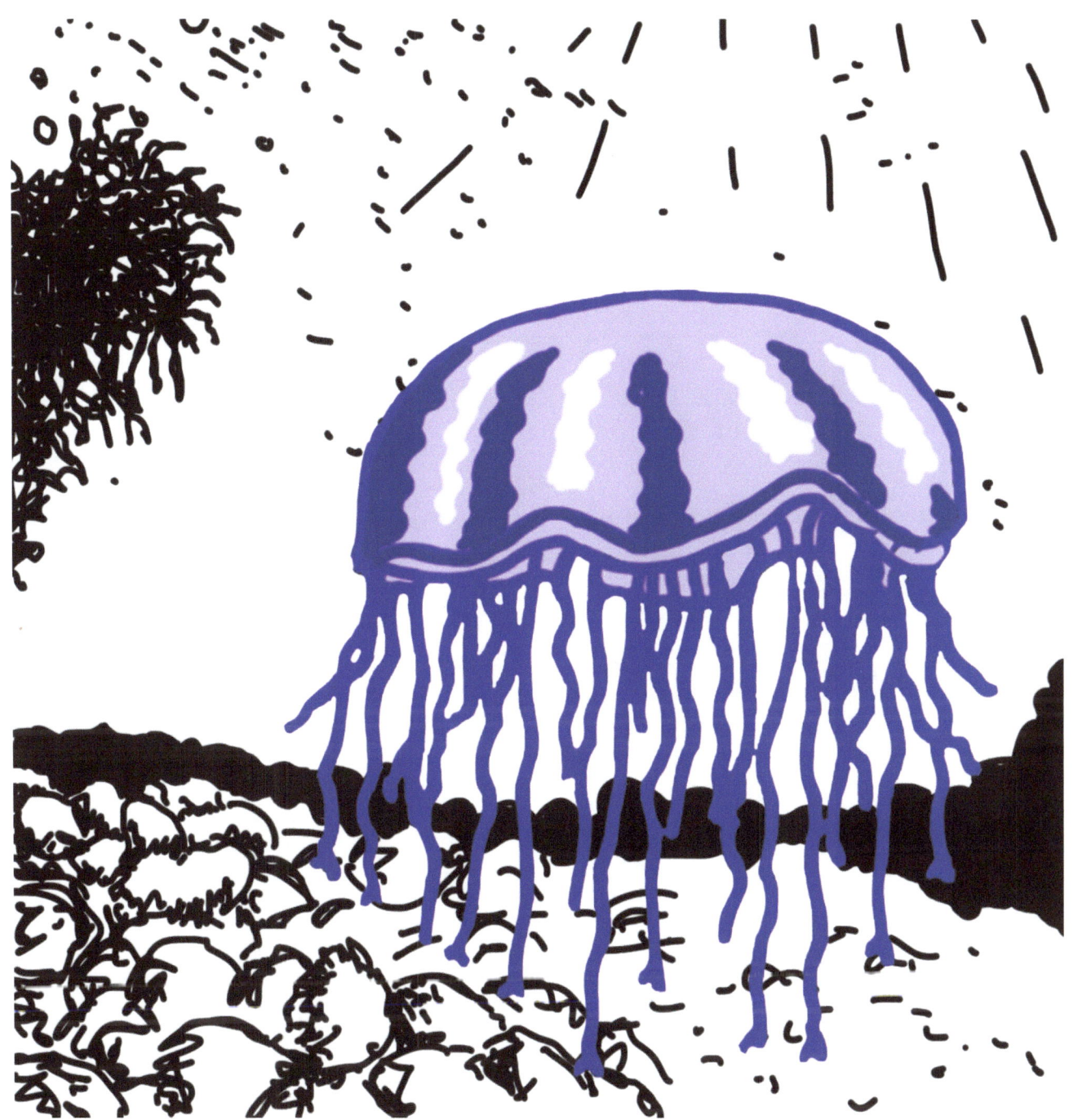

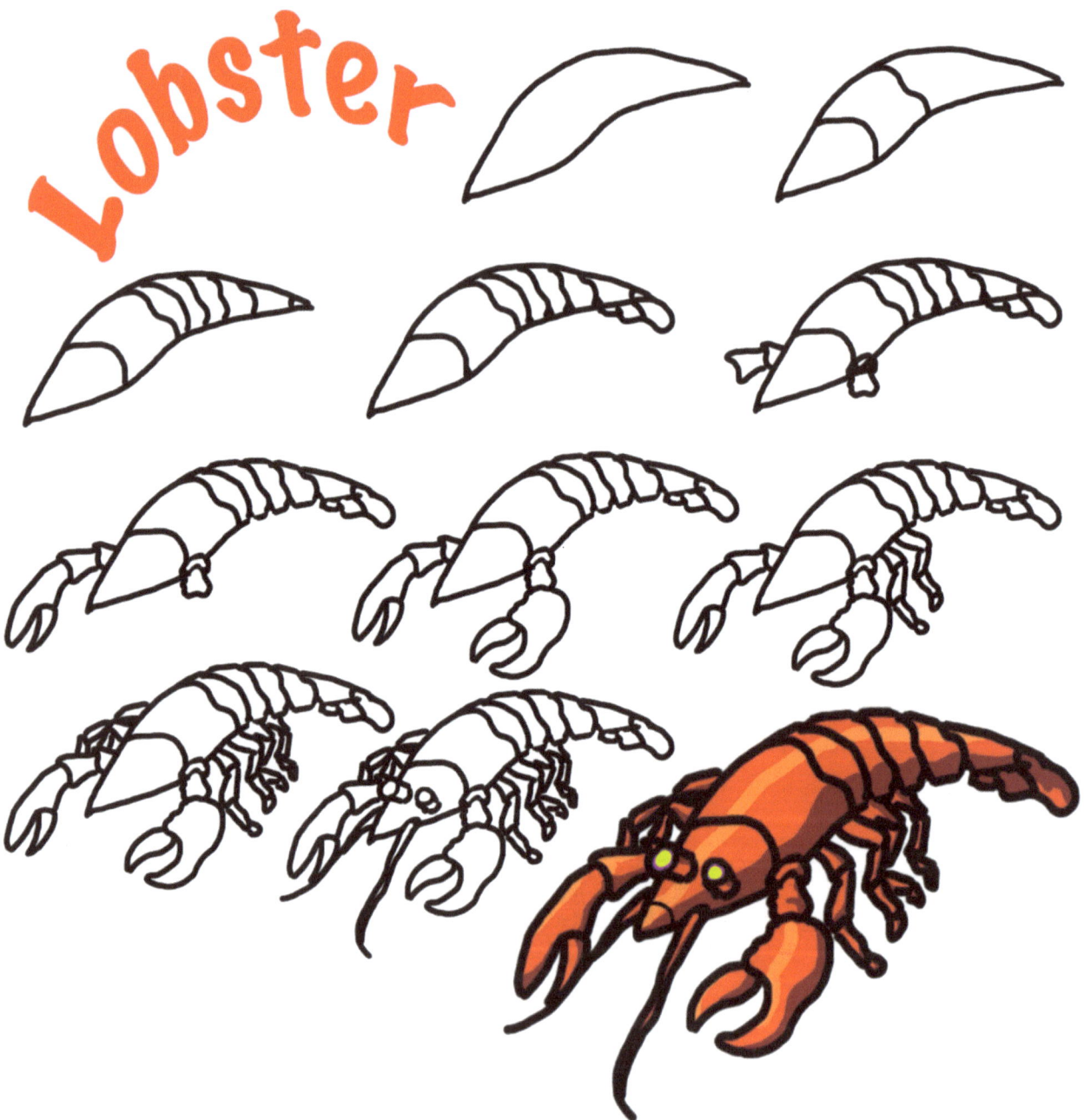

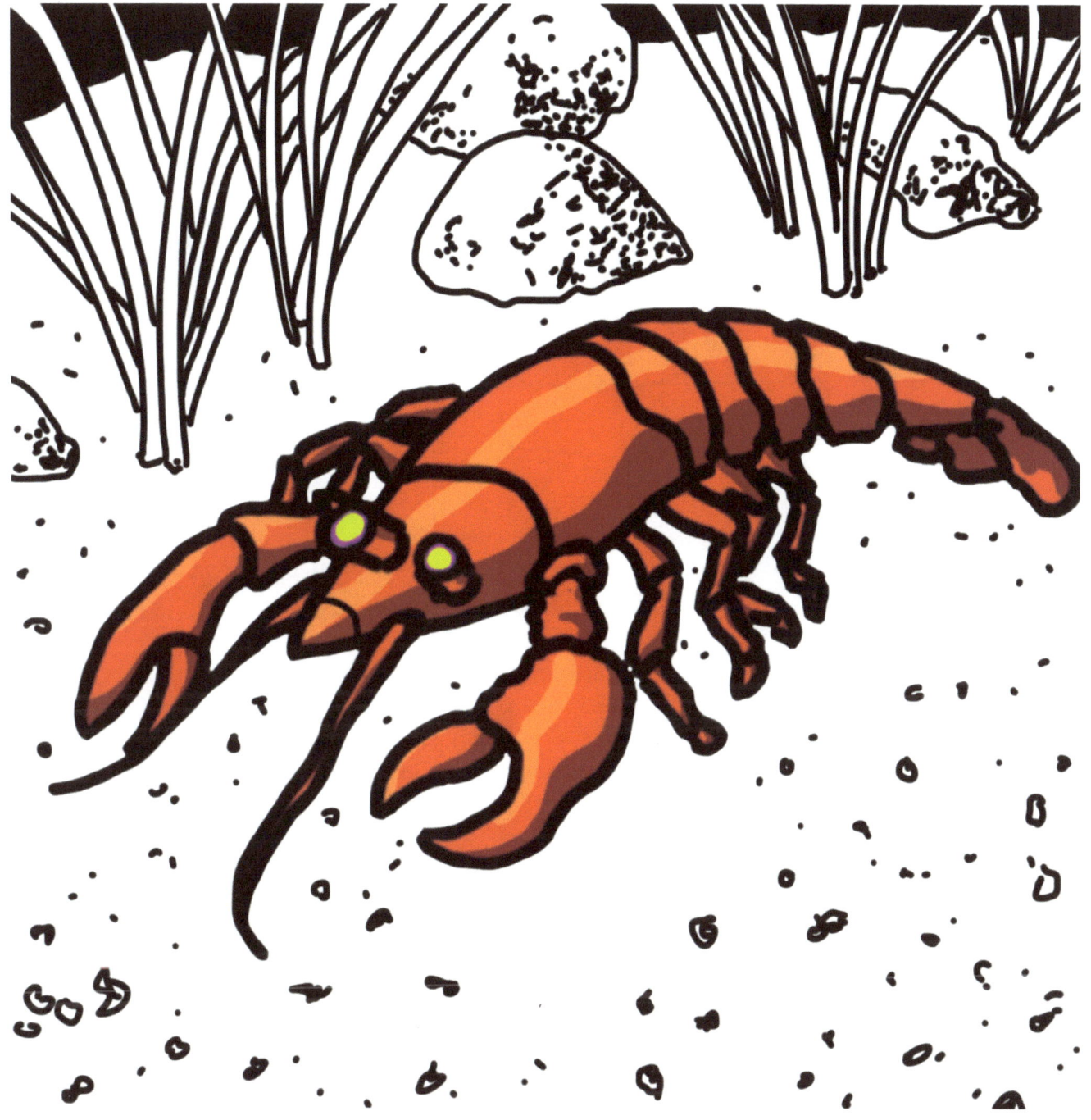

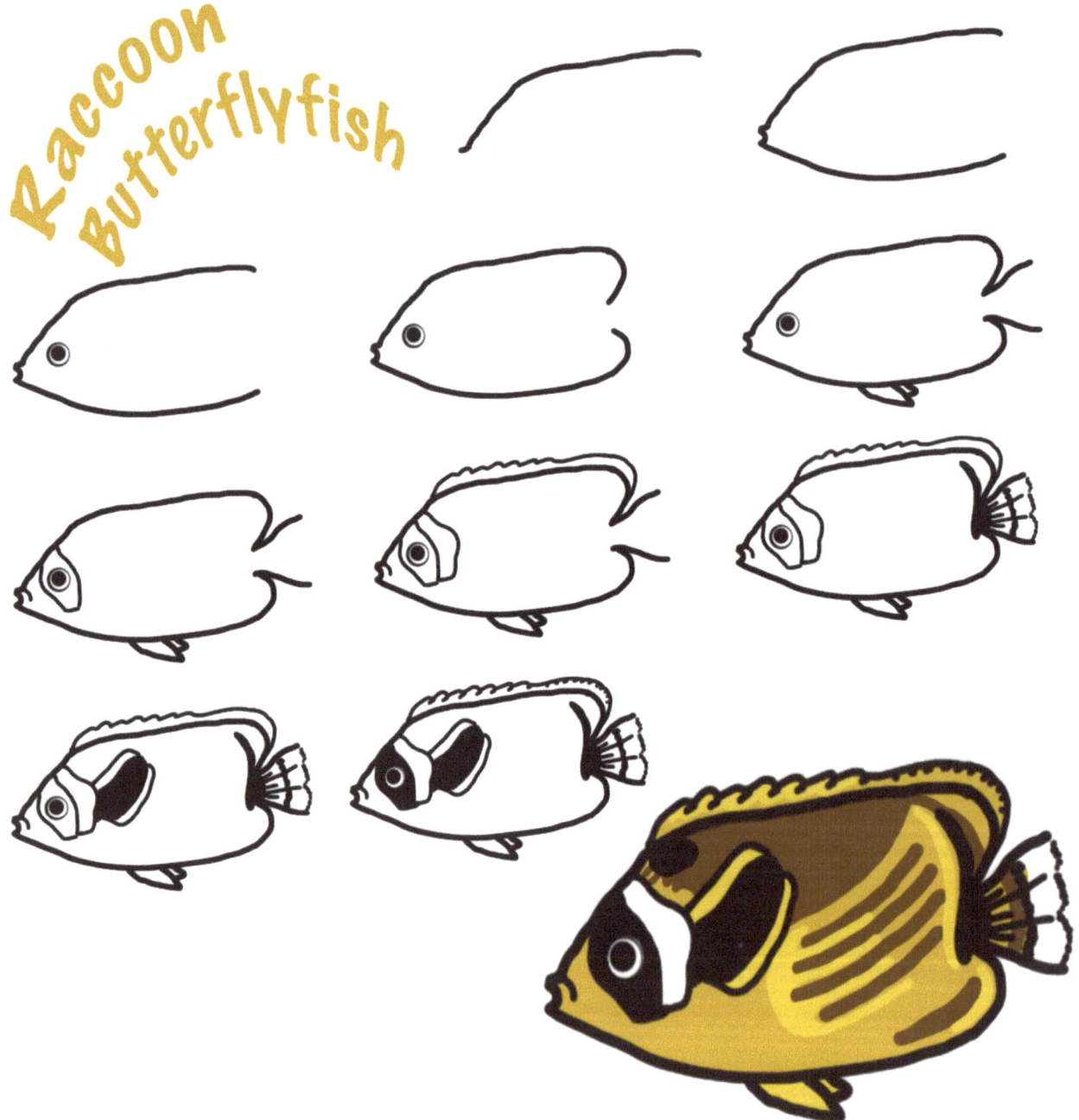

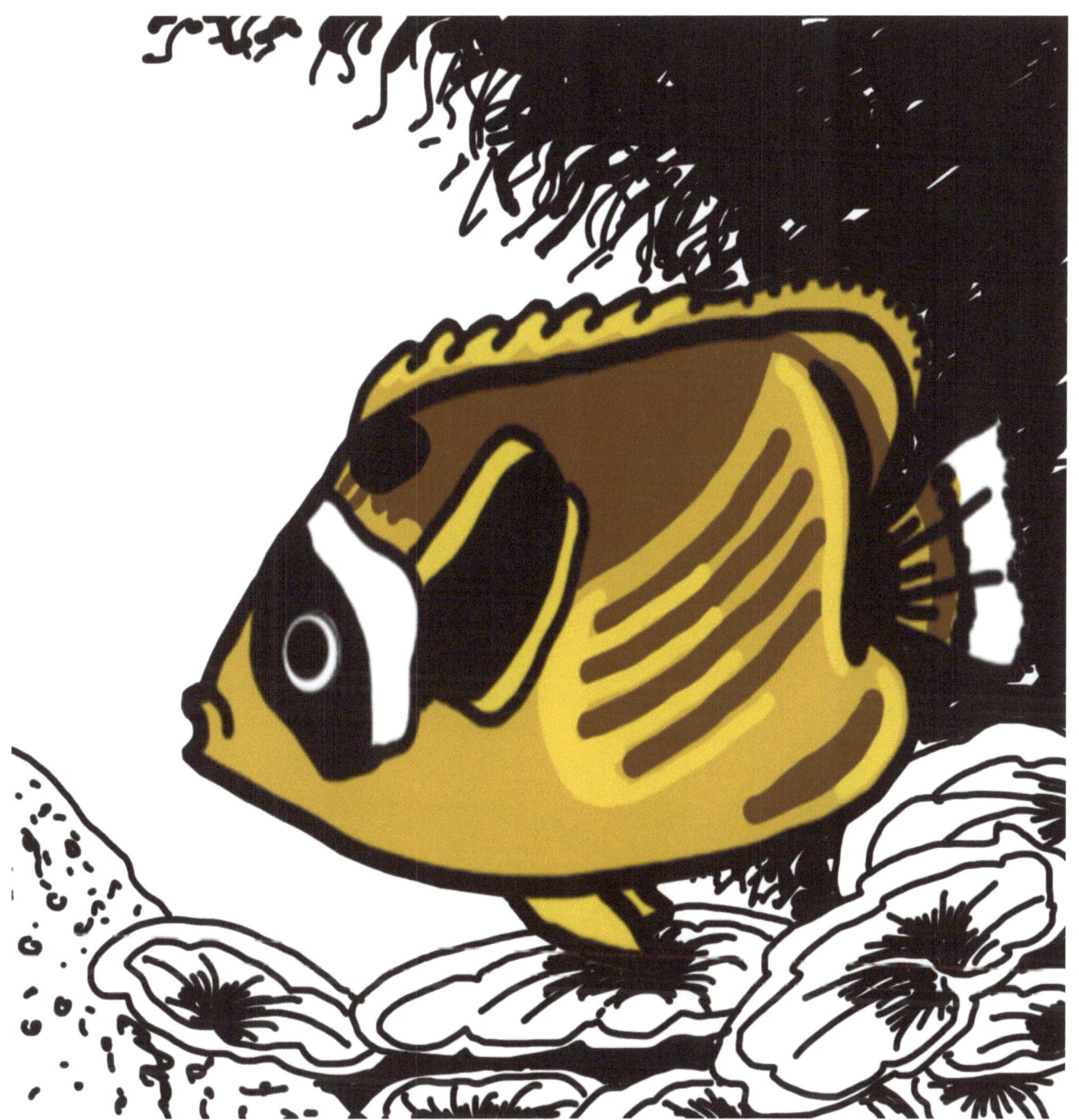

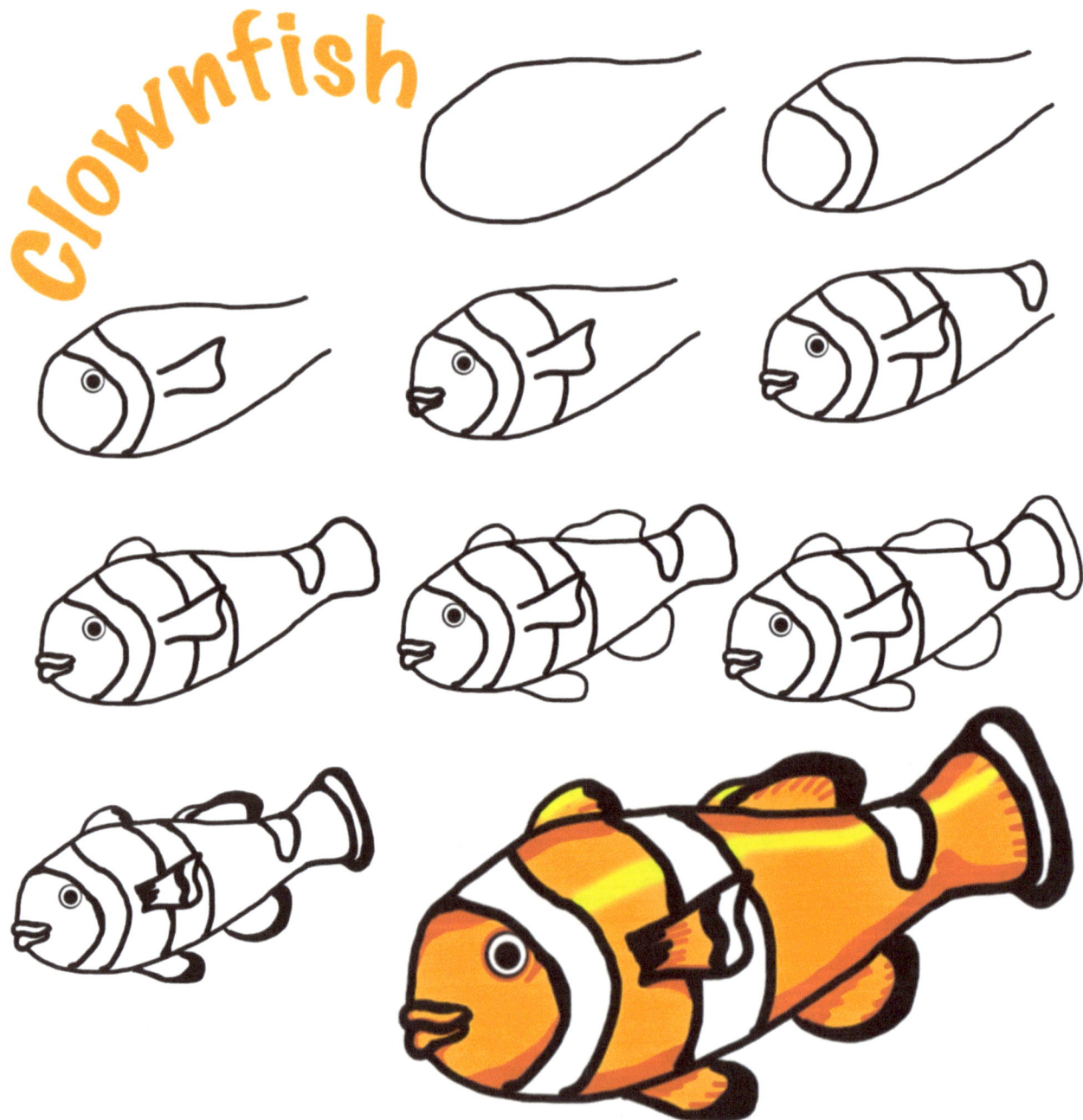

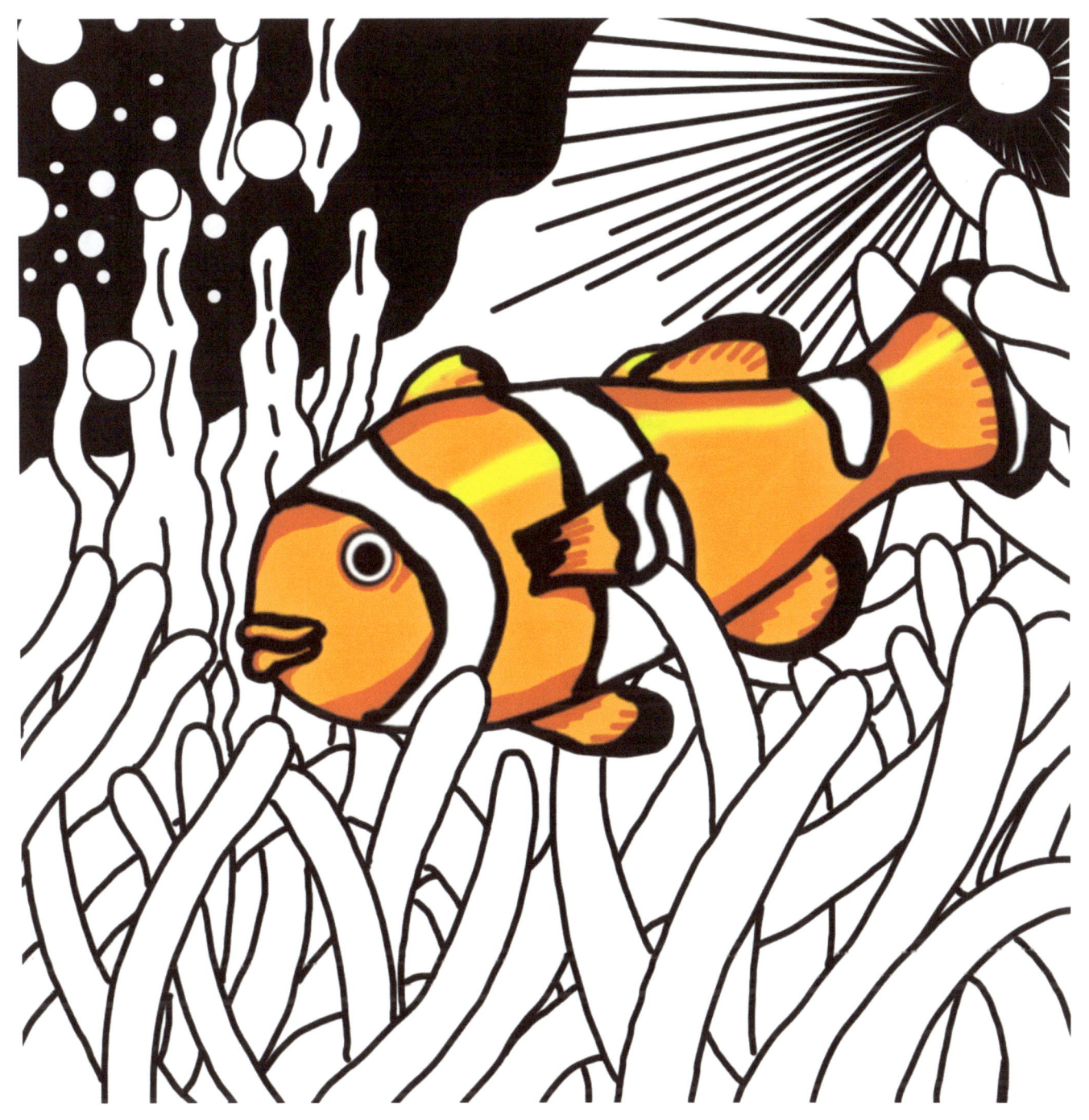

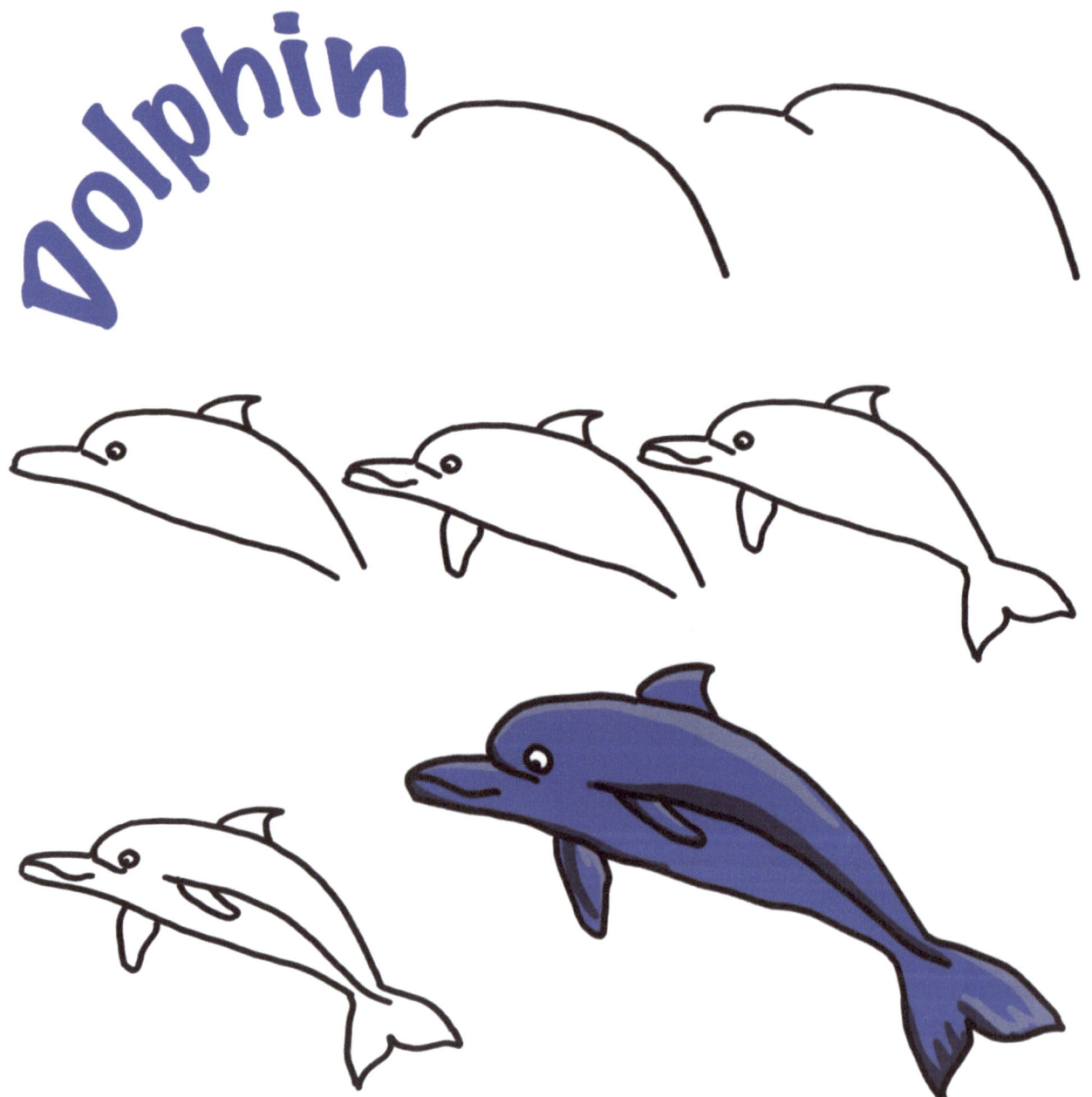

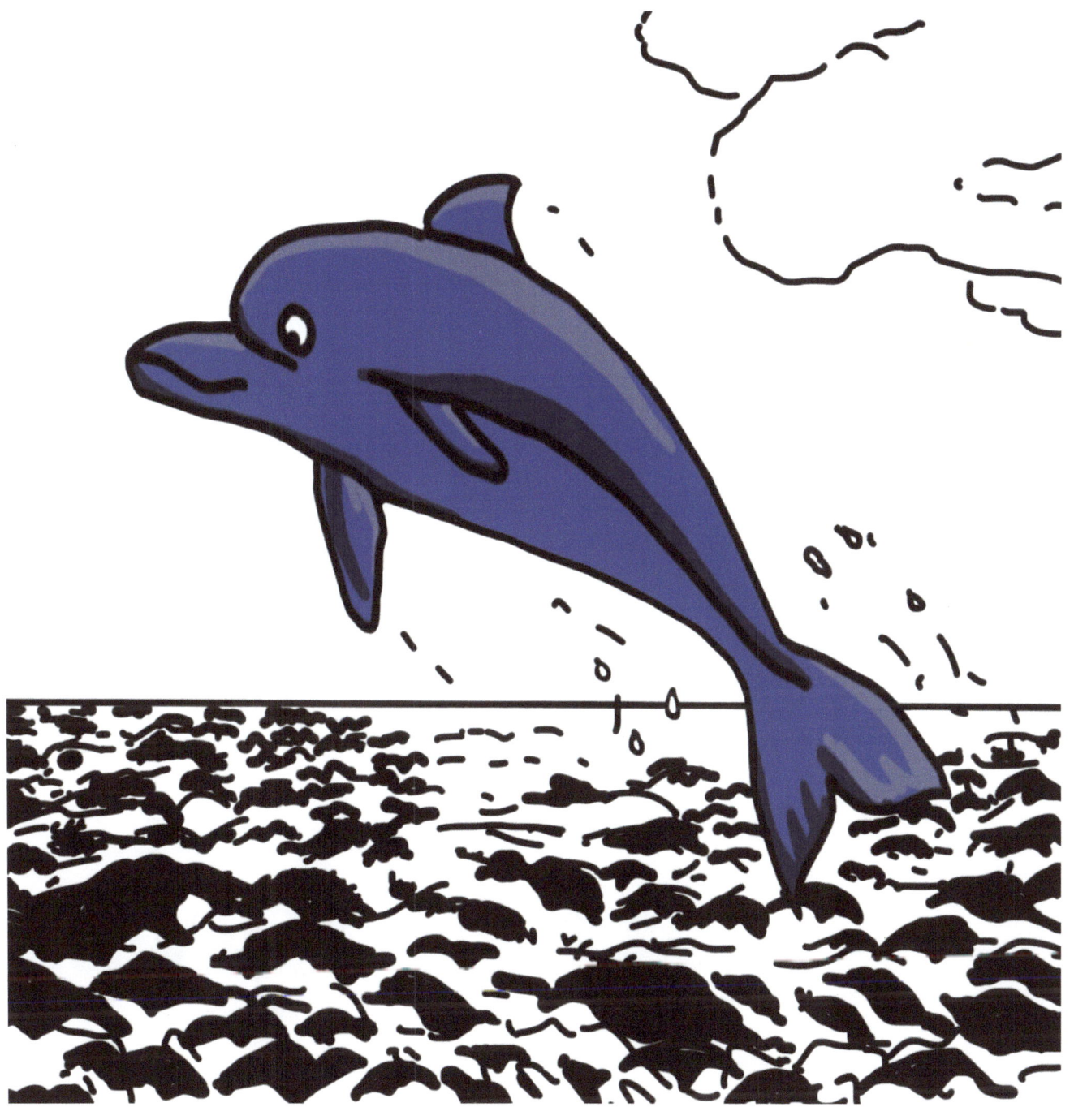

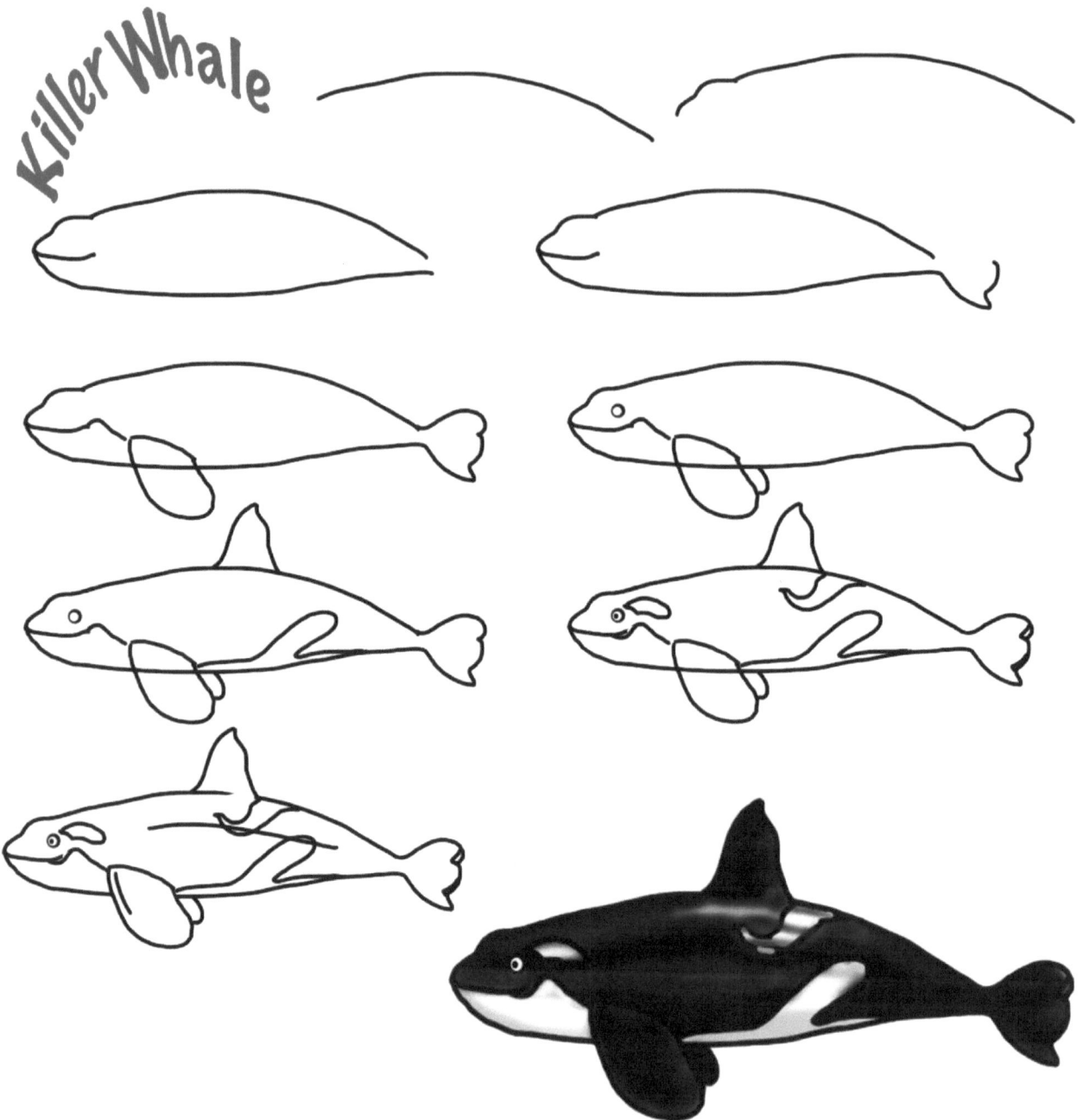

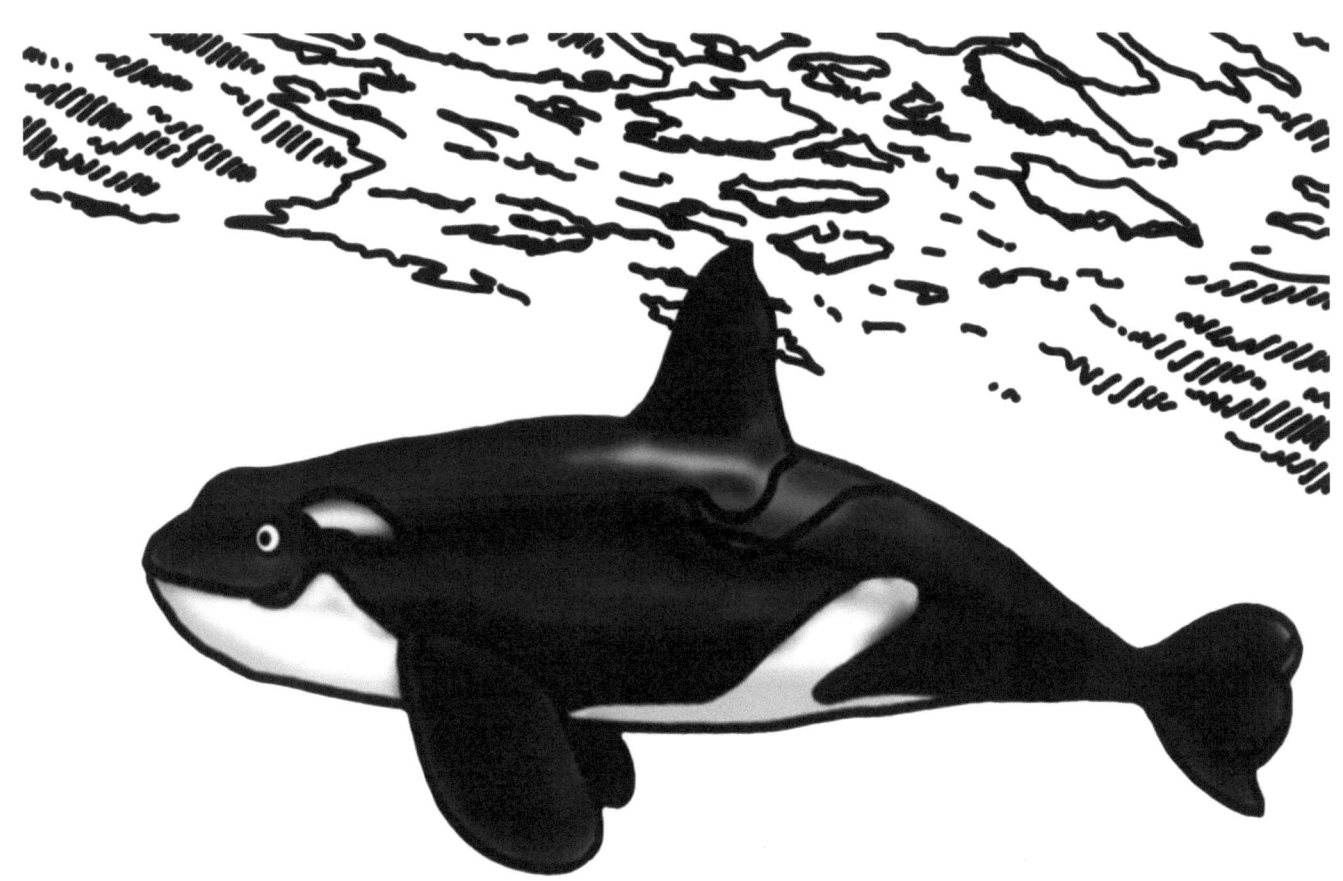

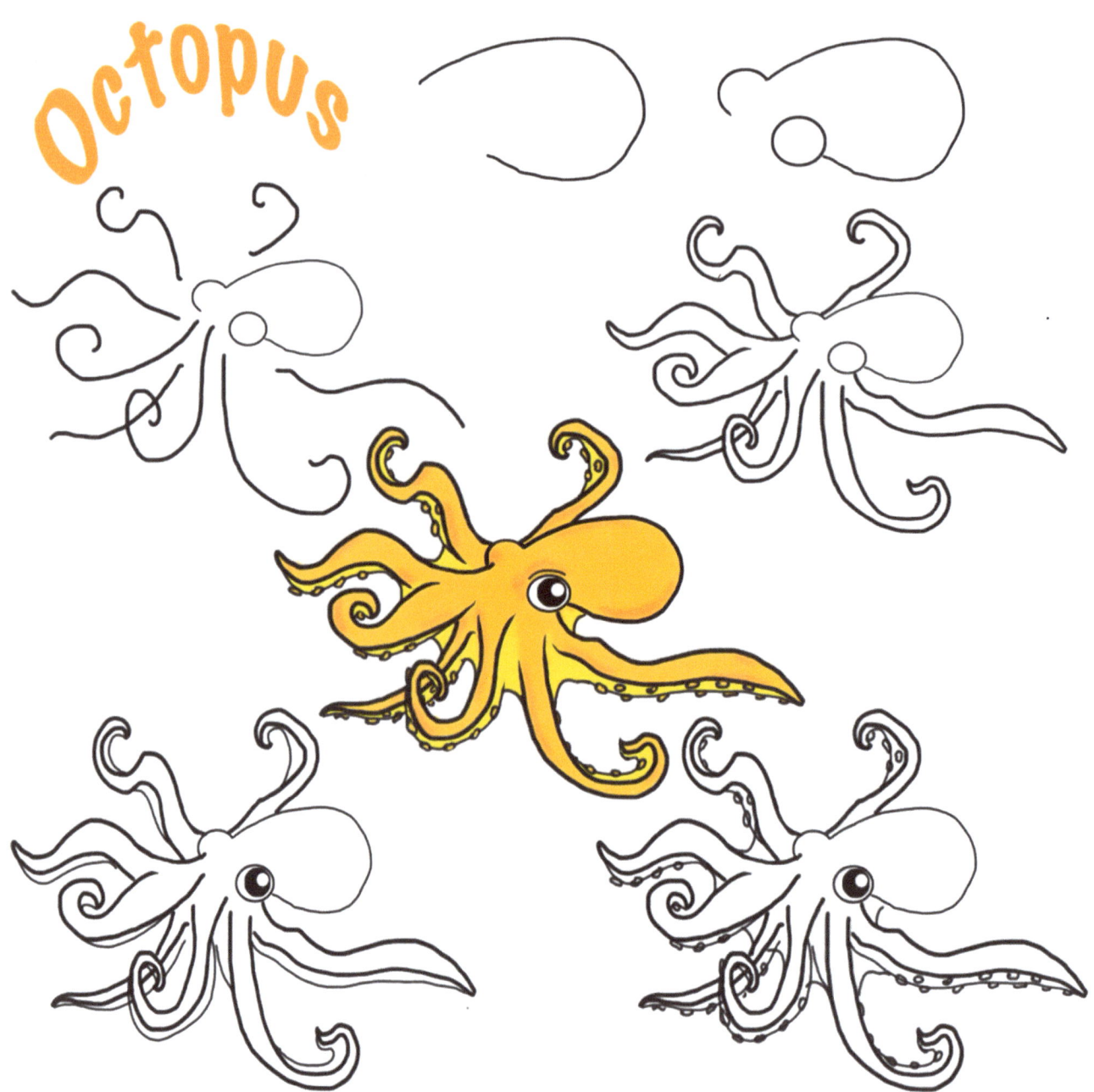

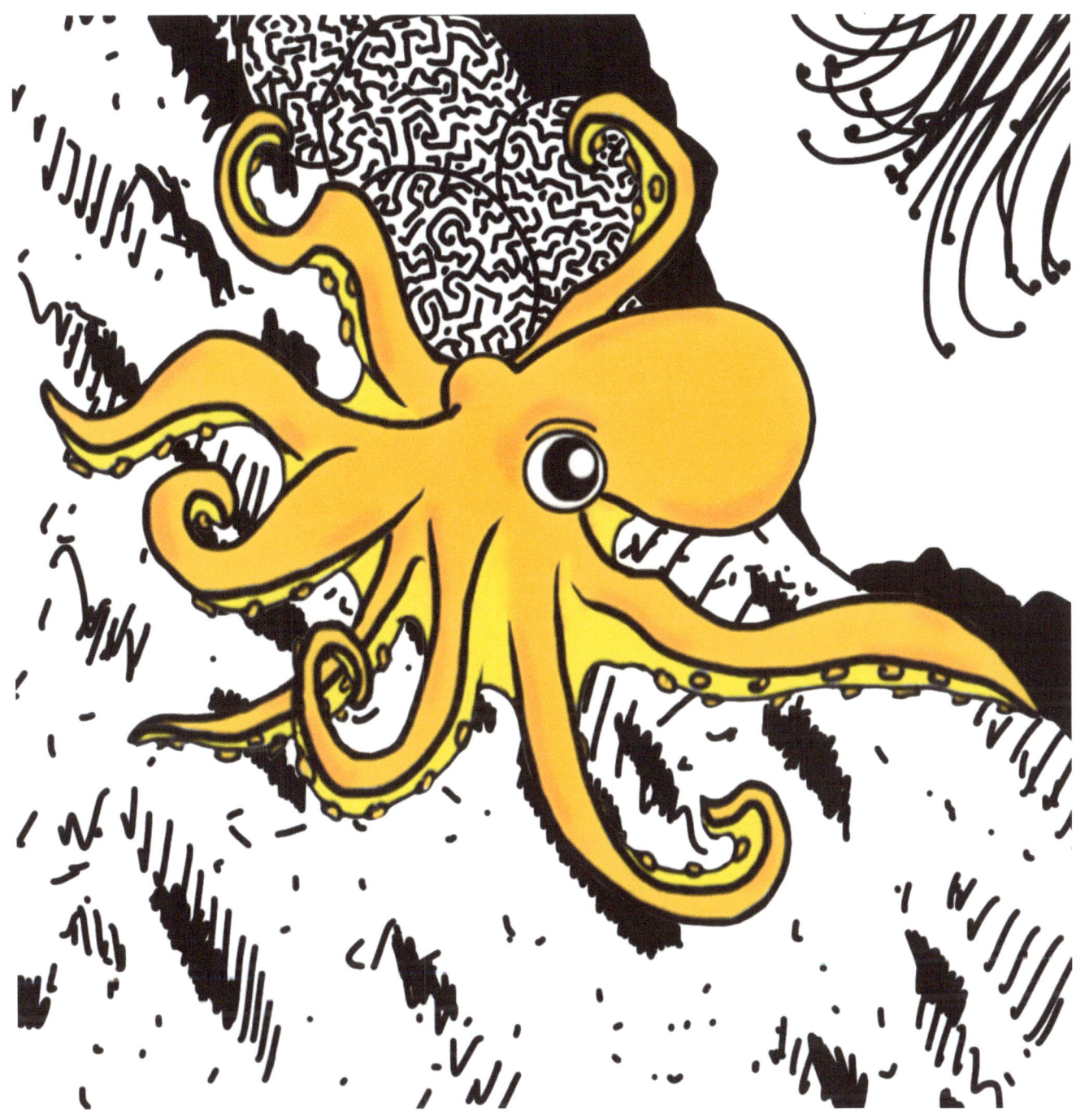

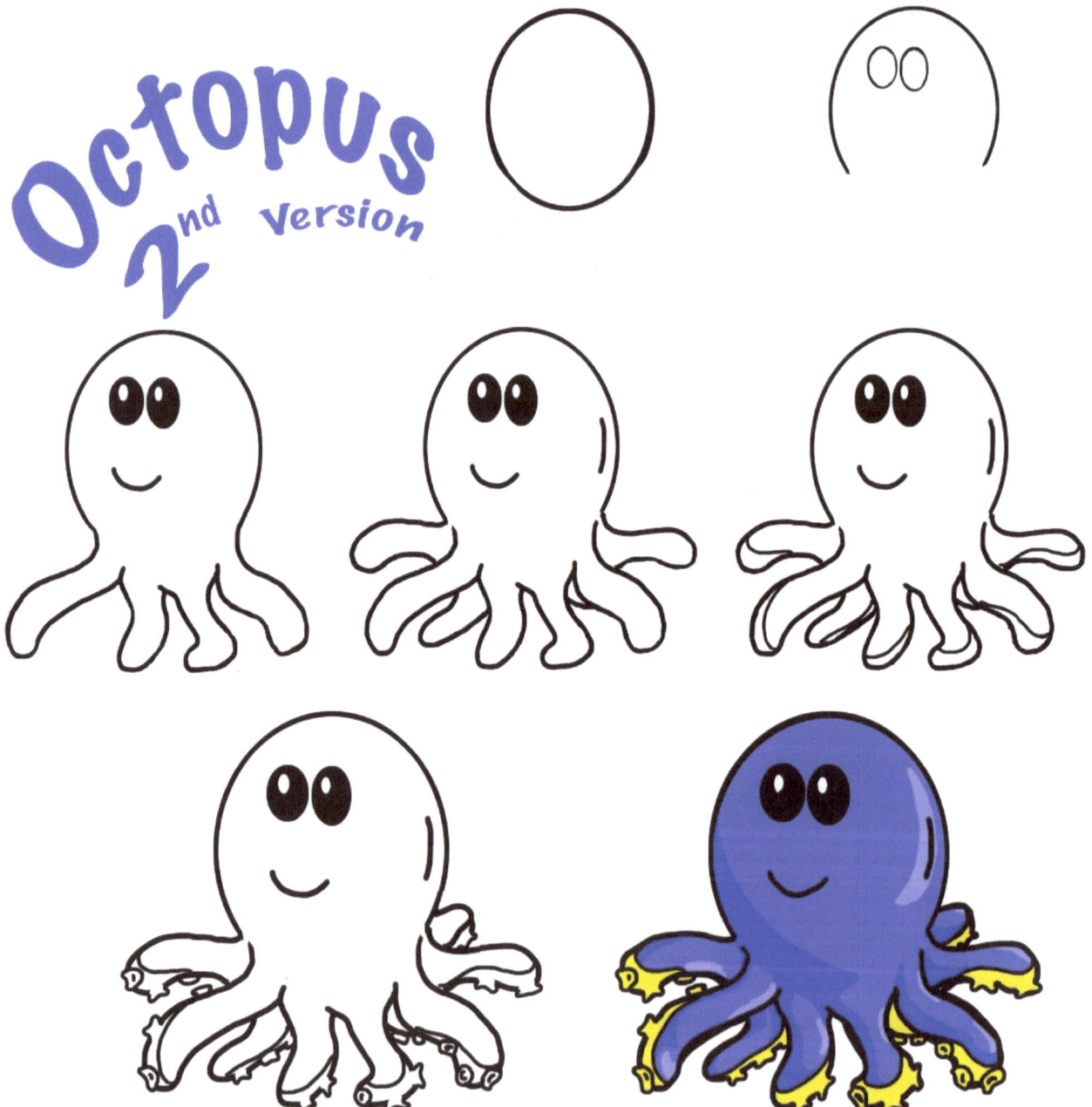

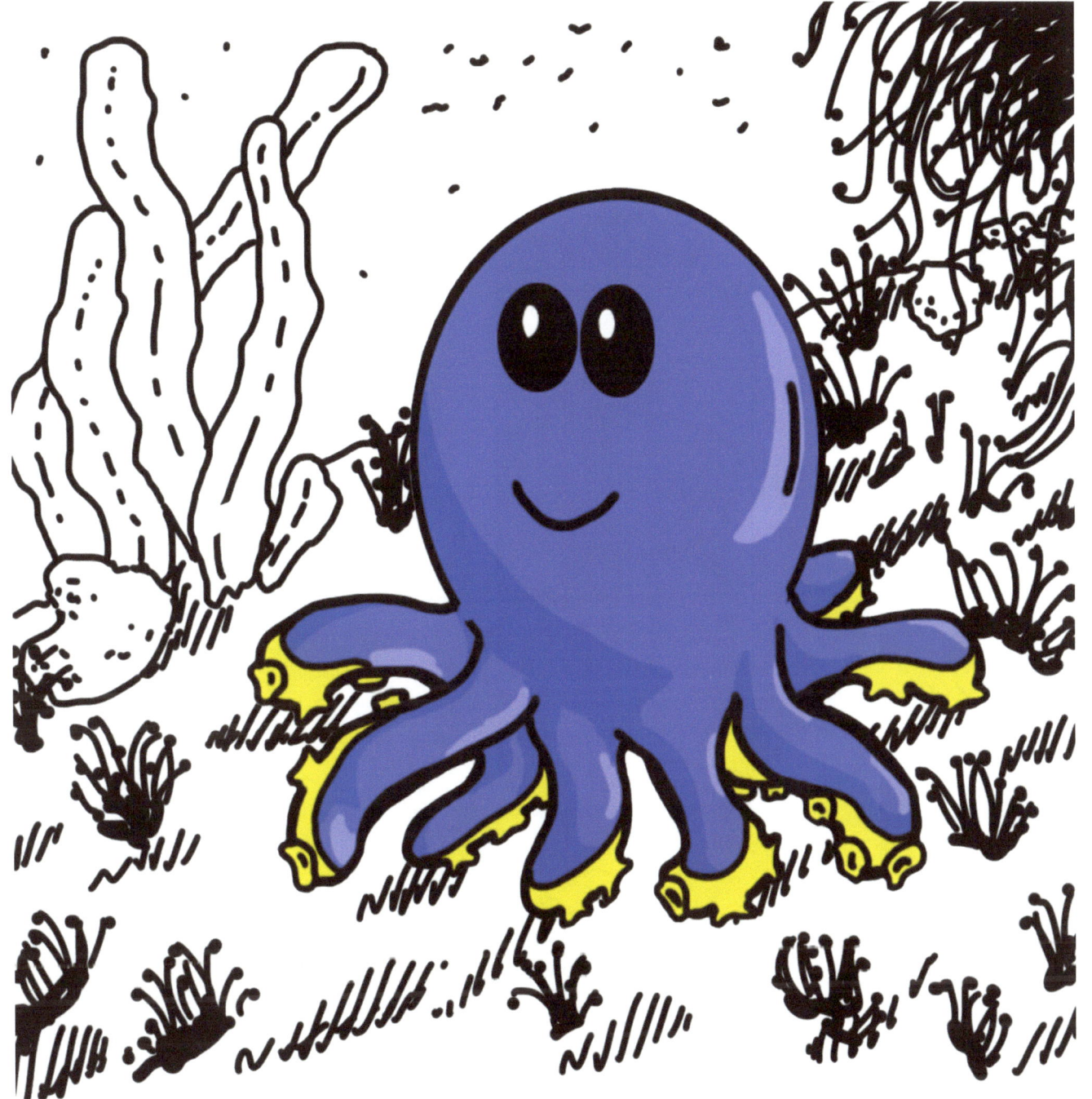

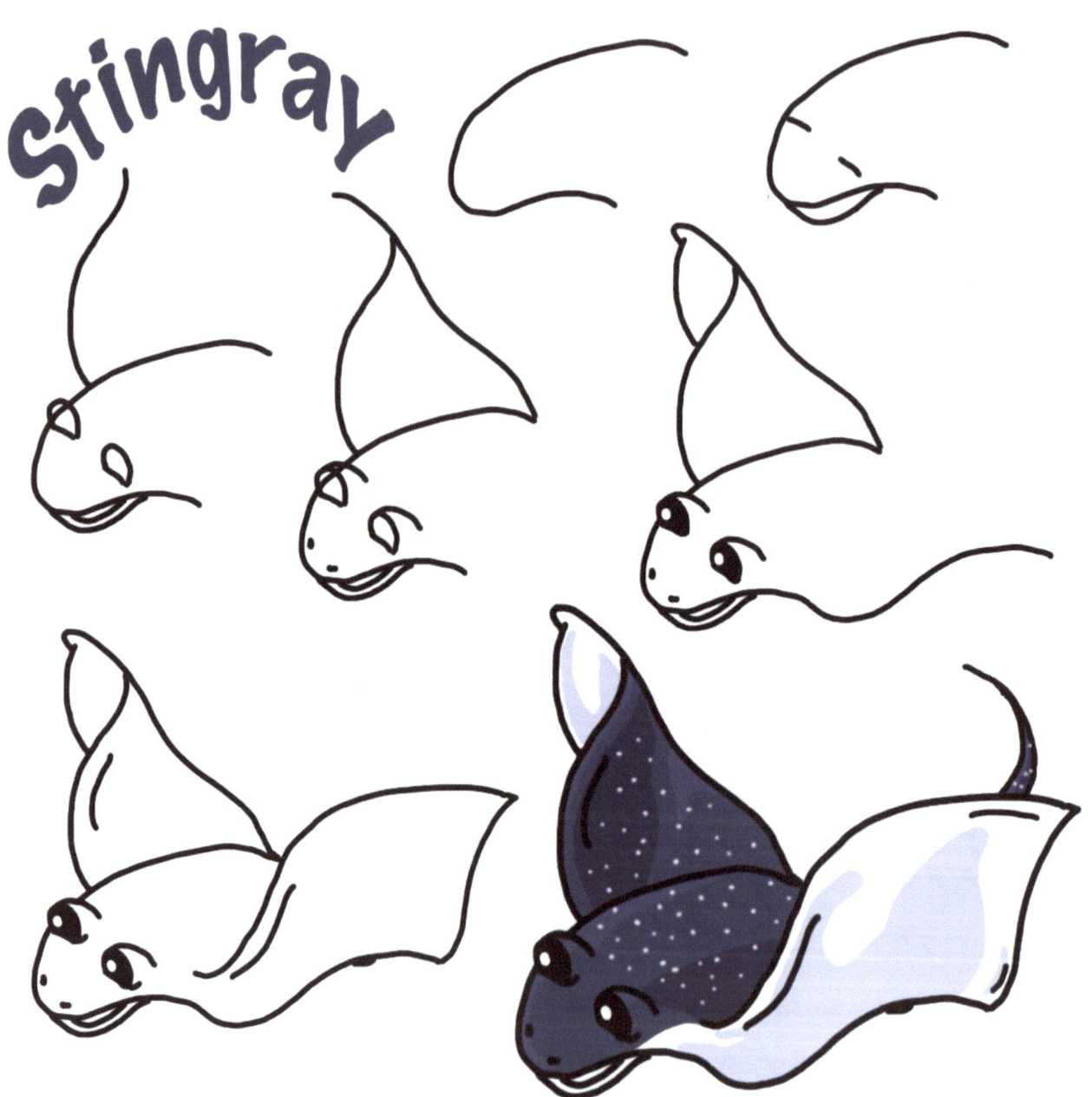

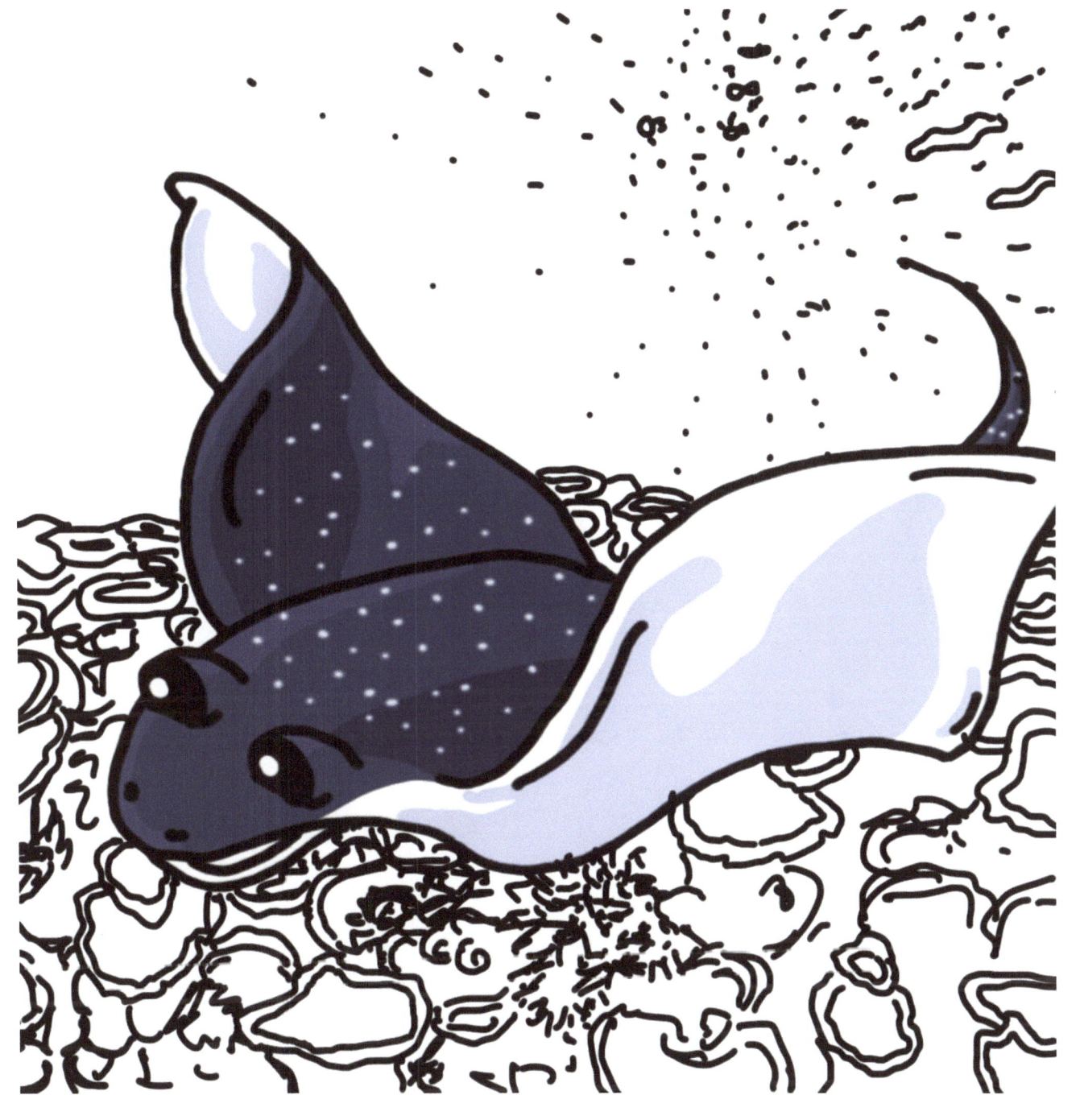

Starfish

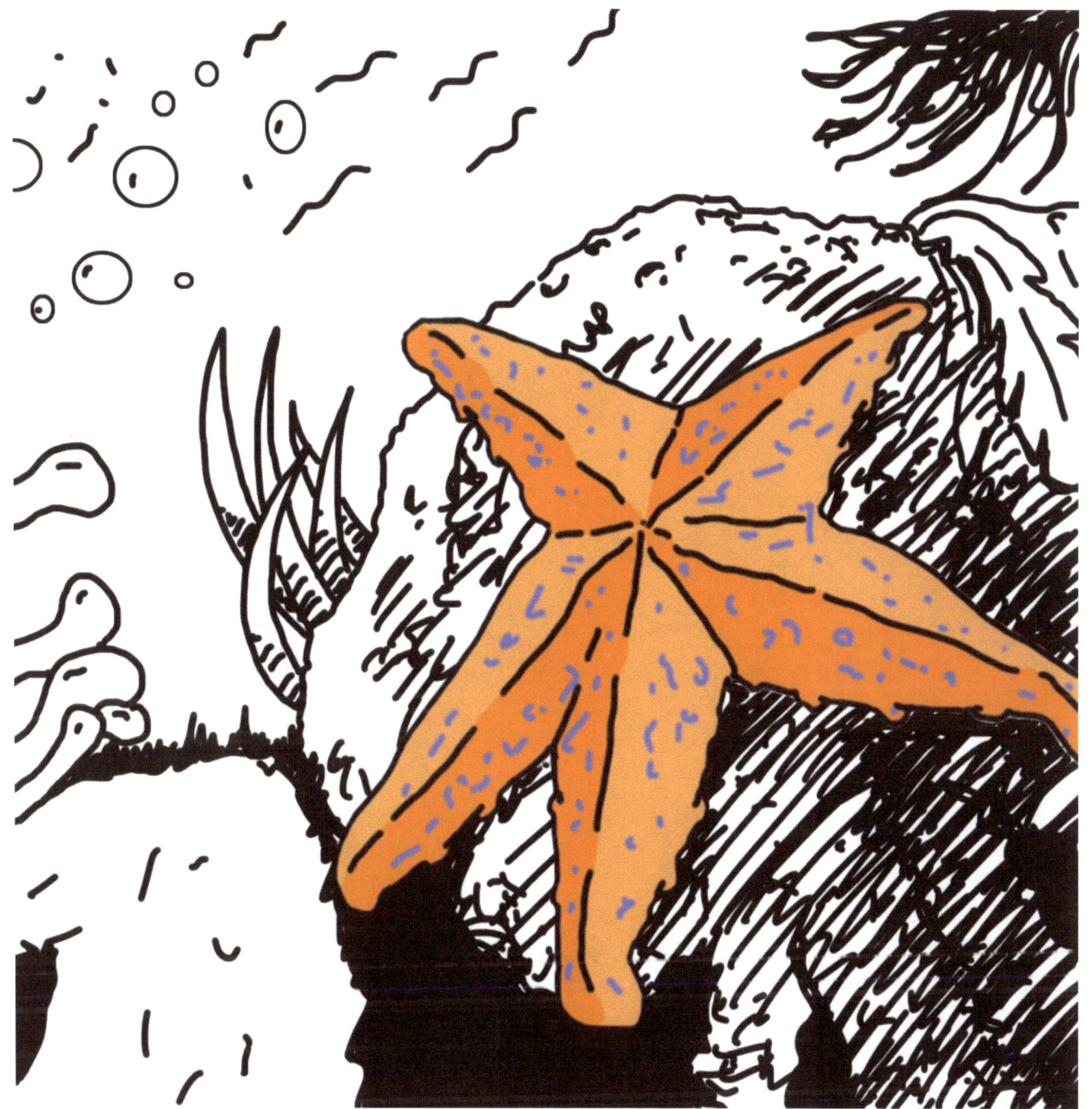

Butterfly Fish

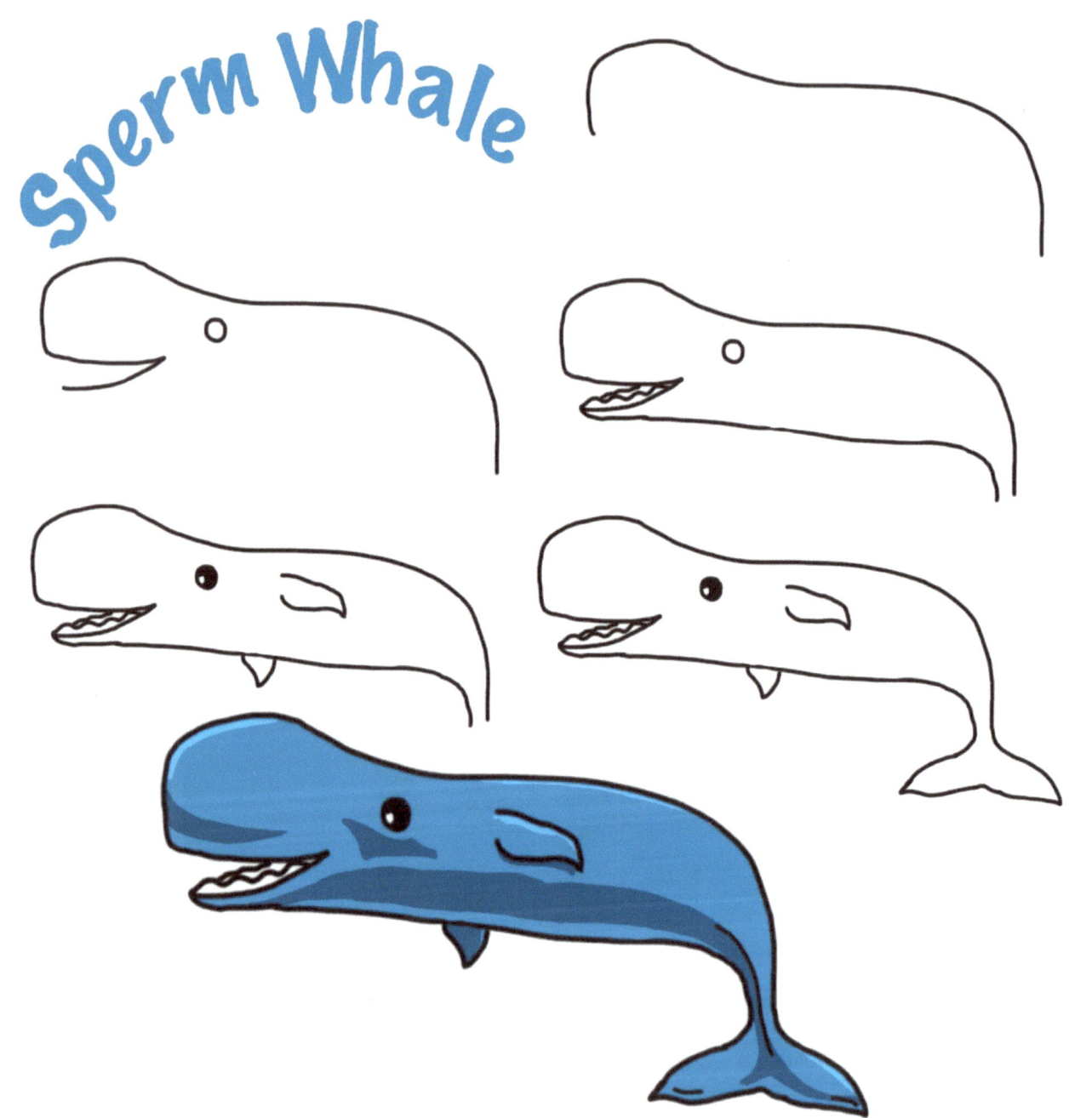

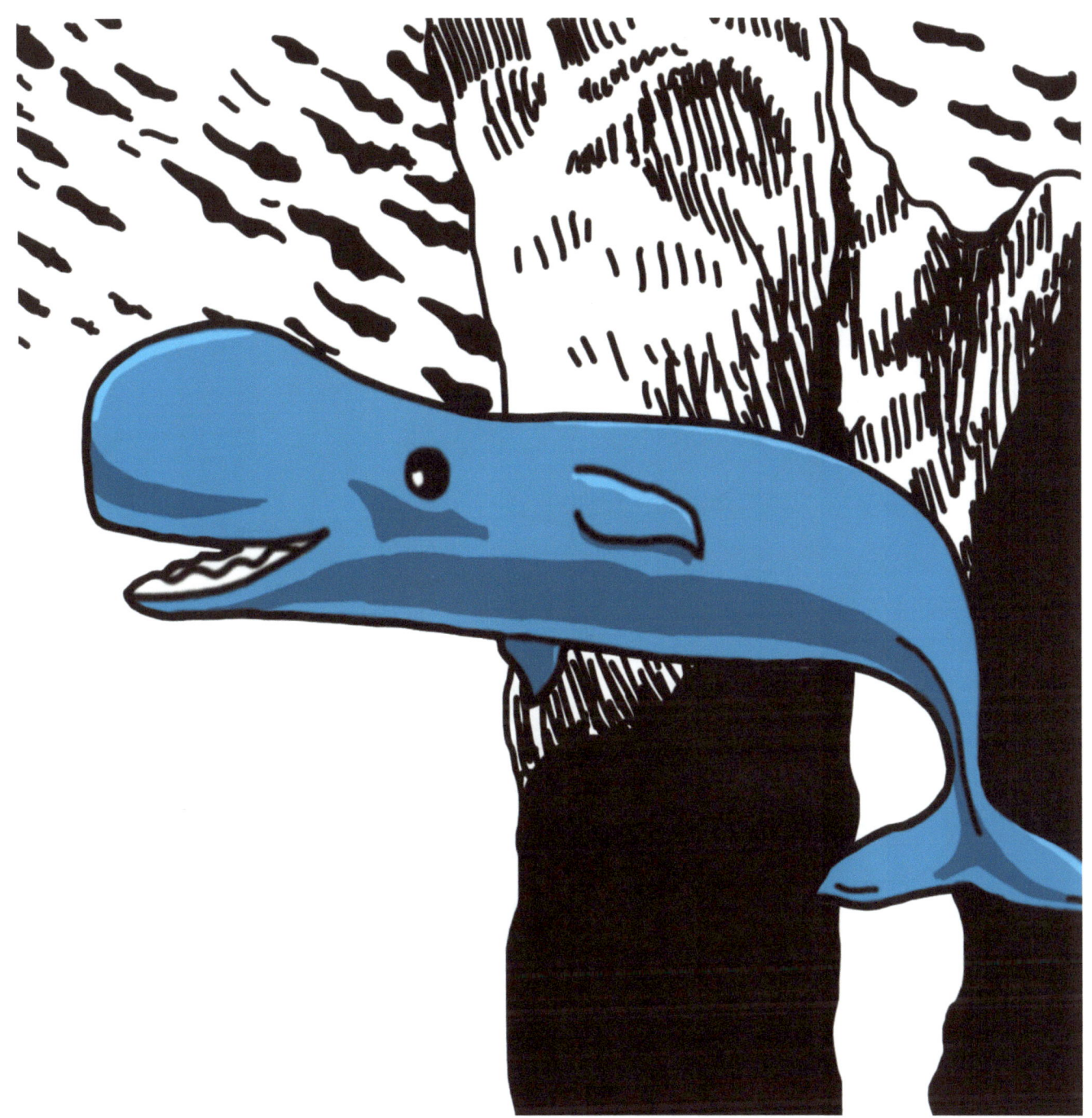

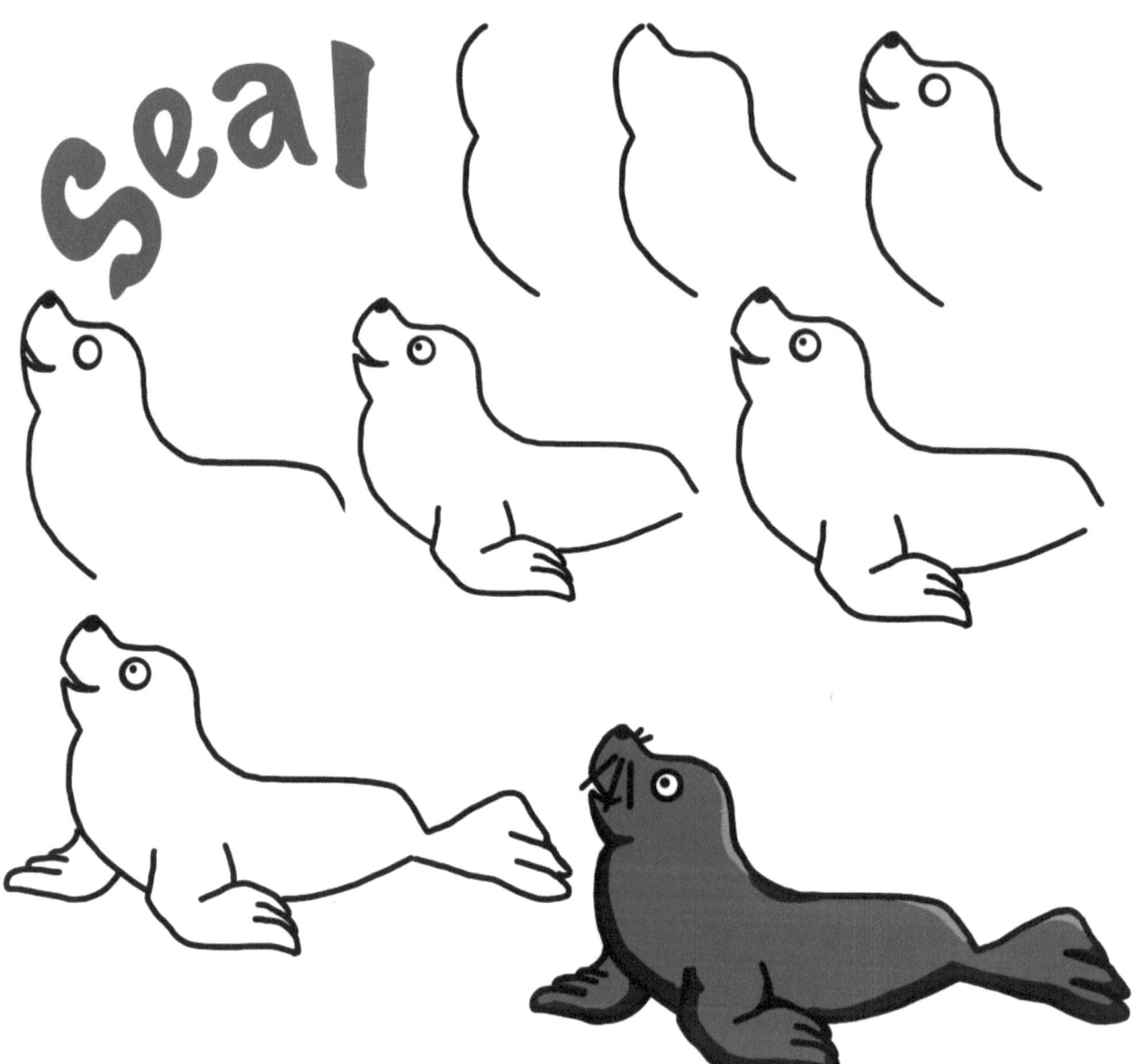

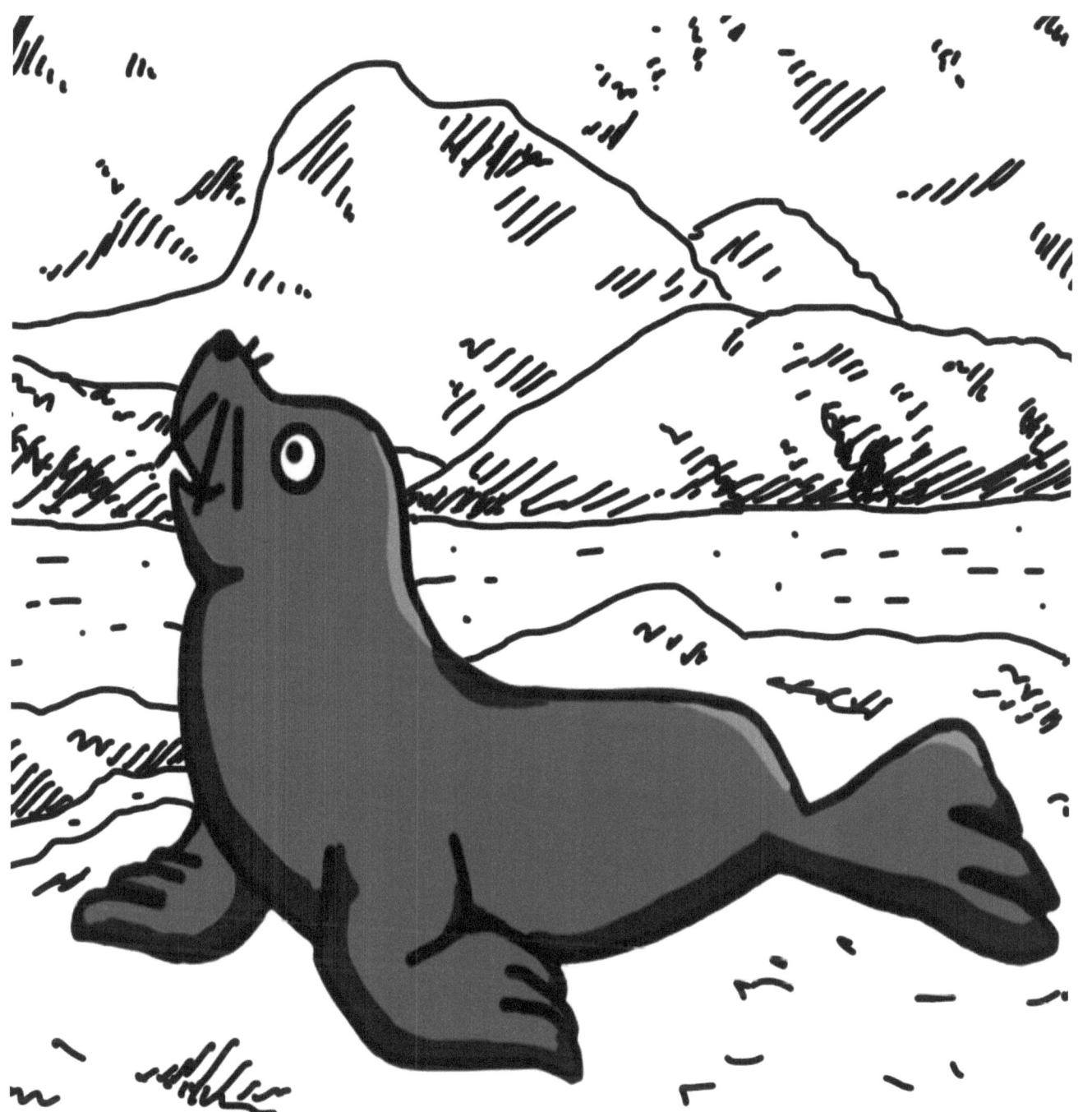

Narwhal

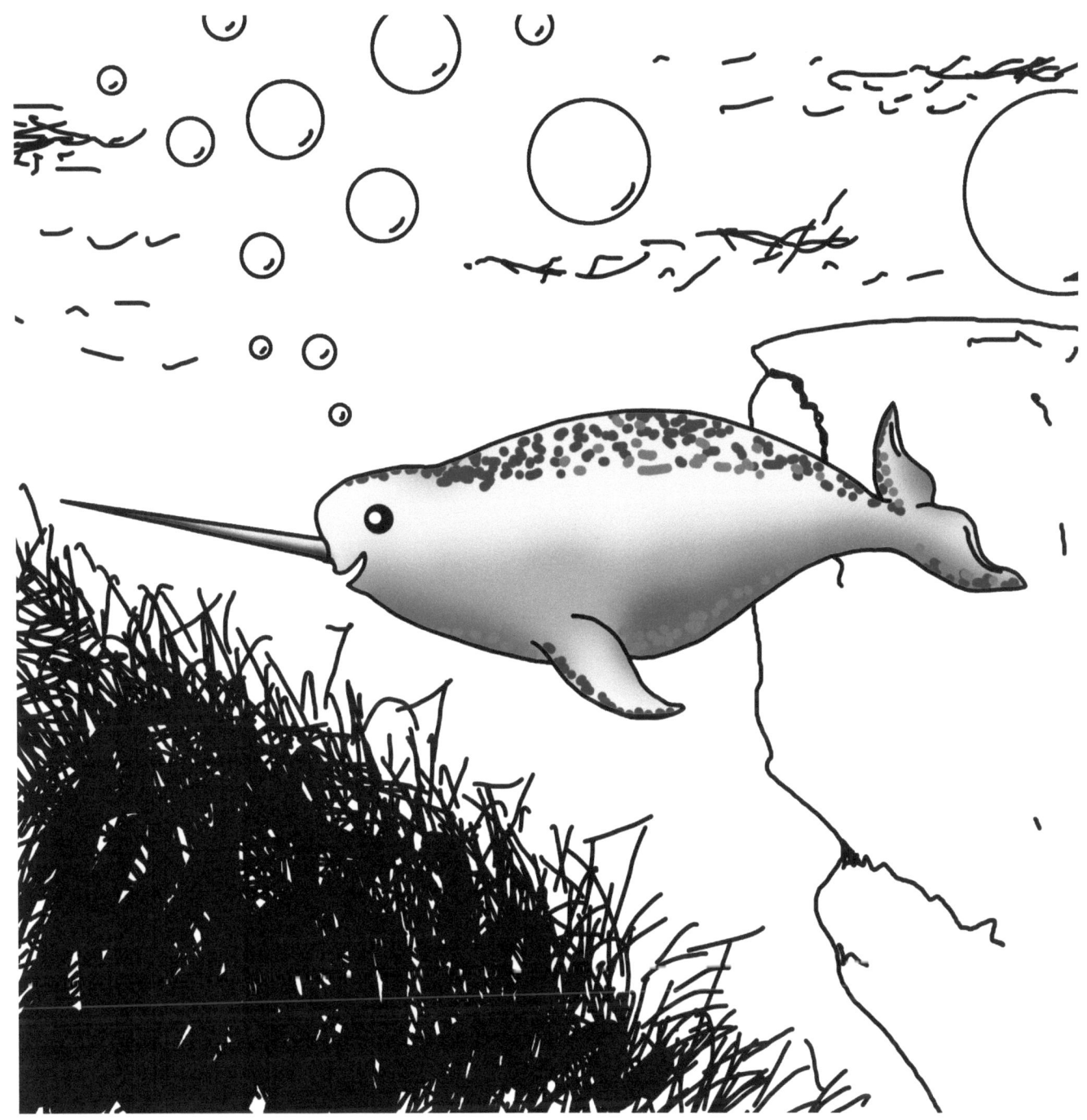

www.ingramcontent.com/pod-product-compliance
Lightning Source LLC
Chambersburg PA
CBHW051055180526
45172CB00002B/645